TITIAN'S LOST LAST SUPPER

TITIAN'S LOST LAST SUPPER

A NEW WORKSHOP DISCOVERY

RONALD MOORE
WITH PATRICIA KENNY

UNICORN

First published by Unicorn
an imprint of Unicorn Publishing Group LLP, 2021
5 Newburgh Street
London W1F 7RG
www.unicornpublishing.org

ISBN 978-1-913491-43-7
10 9 8 7 6 5 4 3 2 1

Designed by Felicity Price-Smith
Printed in Europe by Fine Tone Ltd

CONTENTS

ACKNOWLEDGEMENTS

In the course of three years of research involved in the preparation and writing of this book, I have become increasingly indebted to Patricia Kenny, my art history researcher. Her contribution initially involved searching for specific details which I had requested, after a year she was translating entire monographs from Italian and then countless documents in Italian and forming her own opinions as to attributions. As work progressed, she sourced and organised all the photographic images, applied for copyright permissions and continued to research more difficult areas of Titian's workshop. All the computer overlays, facial recognition software and comparisons are also her work. She could have returned to completing her PhD but her great enthusiasm, intelligence and technical knowledge have been paramount in the development of this book.

I owe a deep gratitude to the editor, Ramona Lamport, for her diligence in reseaching details and elucidation of parts of my text. The value of her suggestions for improvements has been highly significant.

My thanks also to the following people: Robin Holland-Martin, whose untiring enthusiasm for his ancestor, John Skippe, who brought the painting from Venice in 1775 and caused the discovery of vital documentation. Count Francesco da Mosto for kindly helping with information on the da Mula family, from whom the painting was purchased in Venice. Peter Hall and John Cleak for helping with clarity of expression. David Stanton, who provided technical information which clarified identification of Titian's

signature. Hugh Fowler-Wright for his great encouragement and expert advice on early versions of the manuscript. His penetrating, friendly and constructive criticism has been of incalculable benefit thoughout. Professor Alessandra Zamperini of Verona for her enthusiasm and help. Professor Andrew Yates of New York, who examined the manuscript in great detail. Angus Haldane of Haldane Fine Art, for kindly sending a very large format image of *The Four Seasons* by Girolamo Dente. The first good image ever available for many decades. Tudor Price-Jones, artist in New South Wales, Australia for many observations on the hypotheses. Hannah Hiseman, photographer of Ledbury for her high-quality cover photograph. Lorraine Prendergast, who identified some pentimenti in the early stages. James Macdonald of Sotheby's and Francis Russell of Christie's. Professor Andrea Donati, who helped trace Dente's Four Seasons. Professor Richard Cocke, who observed the similarity between the left serving boy, Marco Vecellio and the Vendramin boys. Dr Bernard Aikema for assistance on Girolamo Dente. Brandon Plant Hire of Ledbury. The church of St Michael and All Angels, Ledbury and my wife, Penelope, who has listened patiently to countless drafts and given sound advice throughout.

PROLOGUE

In 2019 I was asked by Ledbury's St Michael and All Angels Church to examine the large-scale painting of the Last Supper hanging high on a wall in the church. It was extremely discoloured by old varnish, had many paint losses and areas of damage and was thought to be a later copy of a master painting. I had briefly looked at it ten years previously when I restored the high altar painting, a rare large-scale copy of Leonardo da Vinci's *Last Supper* in Santa Maria delle Grazie.

I examined the canvas type, cleaned some small areas of the painting in situ to determine the age of the paint, identified some pigments and was able to date the work to around 1580. Initial research suggested that the painting was not a copy and conservation was allowed to commence.

As work progressed and layers of old copal and mastic varnish were removed, many features became apparent which indicated that the picture was far more interesting and important than initially suspected.

Examination by optical microscopy in visible and ultra violet light, 20x binocular microscopy and pigment analysis showed evidence of many changes made. Some of these alterations have faint, juxtaposed images as the top coat of paint has become translucent. Some of the pentimenti are very clear and can be dated as having been altered at the same time. In addition, a tiny date was discovered contemporaneous with the relevant paint surface, indicating that during the later stages of the painting's creation, in fact 1576, it appears that the decision was made to

create a group of portraits, one being highly important of Titian as a young man.

To validate this claim we tried using computer facial recognition software and then overlaid the images on a video. For the purpose of this book we used a series of images captured from the video.

Although we can place several important painters in the workshop until 1580 – Emanuel Amberger, Tintoretto and Palma il Giovane – we have documentary evidence that 1580 is the last date of payment to artists brought in by Marco and Pomponio Vecellio, Titian's nephew and son, and the final date of completion of our *Last Supper*.

The exciting discoveries made during conservation prompted further research and this has now taken more than 10,500 hours, the translation of many Italian documents, books and articles, and the examination of countless Venetian and North Italian paintings to determine the source of our *Last Supper*.

A family member kindly trawled through old documents and letters and discovered a vital quote from his ancestor John Skippe, speaking of his purchase of the *Last Supper* in Venice in 1775. We traced the progress of the painting and checked dates to ensure that this was the actual painting.

Following the basic discovery that this was an original work from Titian's workshop, we further discovered the small Titian signature and date (which was recorded by Skippe in 1775 but which was later badly damaged as to be almost illegible), together with another monogram by Girolamo Dente and a further date.

The Titian signature was filmed in ultraviolet light and a series of still images from a video were slowly overlaid comparing a known Titian signature with our own. The tiny damaged letters matched sufficiently to be certain that this was indeed the signature seen by Skippe in Venice.

Next we investigated all the artists working in Titian's shop during the period 1560–80 and identified those whose work may, we believe, be found in this *Last Supper*. We also postulate that Titian's own hand may be seen in the underdrawing and supply evidence of this.

The following book is the result of all that research and is divided into eleven chapters, including detailed analyses of

the workshop, details of technical examinations, the sources of the painting, the development of the workshop and changes it underwent when Titian left Venice and travelled to Germany, together with hypotheses as to identification of the artists involved and the subjects of the portraits.

Ronald K. Moore
Patricia Kenny

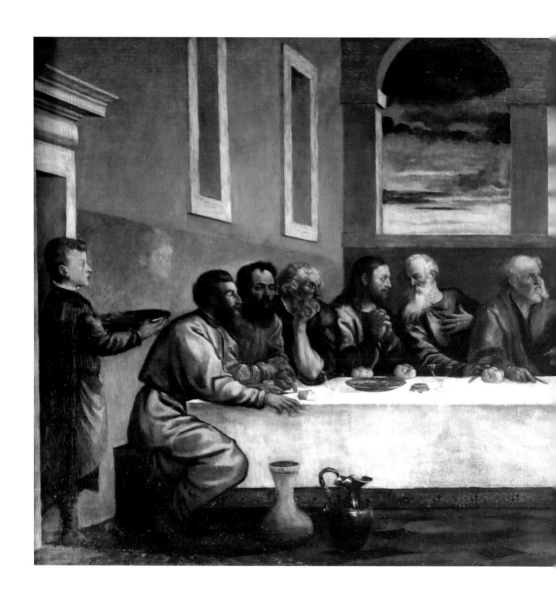

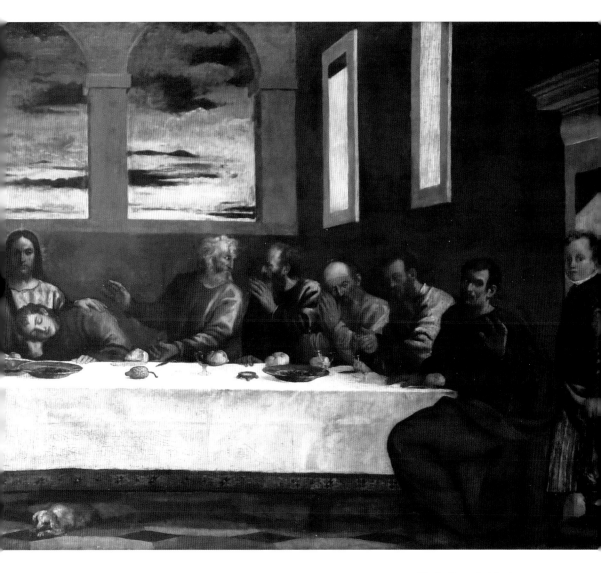

The Ledbury *Last Supper*
Photograph by Hannah Hiseman

1

THE HISTORY OF THE LEDBURY LAST SUPPER AND THE SKIPPE AND MARTIN FAMILIES

THE TRAVELS

John Skippe was born on 7 July 1741. His parents were John Skippe (1707–96) of Ledbury and Penelope Symonds (1716–1806) of Pengetheley. Skippe died, unmarried, on 14 October 1812.

He graduated from Merton College, University of Oxford in 1760. Whilst there, Skippe became friends with John Malchair (1729–1812), a German musician and artist, from whom it seems likely that he learnt much about painting. Malchair visited Skippe's home, Upper Hall in Ledbury, and drew it on 10 September 1760.

Skippe travelled widely, his initial trip being to Italy via Paris in August 1766, where he first purchased a painting, although which one is unknown. He then visited Lausanne, Turin, Bologna and by November he had arrived in Rome, where he stayed until March 1767 when he went to Naples. In June he travelled to Florence, Bologna, Ferrara, Venice, Padua, Verona and Vicenza, returning to England via Strasbourg in November.

His second trip was in June 1772, when he visited Venice before travelling to Padua in 1773.

His third journey, in May 1775, was by sea to Leghorn, and then on to Florence, Bologna, Ferrara, Padua and Venice in October, which inspired him to travel further east. In November he visited Alexandria, Cairo, Cyprus and the Levant, mainly along the coast, returning to Venice in June 1776, where he probably remained until May 1777 when he returned to England.

Having prolonged his grand tour of Italy comprising three trips spread over eleven years, he may not have returned, but during those years succeeded in purchasing a number of paintings and drawings. After this, Skippe spent little time in Ledbury and it seems that his parents possibly registered disapproval of his many purchases. At this time, knowledge of Old Master workshops (botteghe), studios and copies was very limited and, as we will see, even Vasari noted on the complexities of Titian and his workshop. It is unlikely that Skippe possessed sufficient knowledge to recognise an Old Master painting and doubtless Italian dealers took advantage of him and many others. However, the master drawings he collected were generally of better quality.

THE ART

Christie's catalogue of the Skippe drawings sold in November 1958 was catalogued by Arthur Popham, an expert in Renaissance drawings and Keeper of Prints and Drawings at the British Museum.

In his youth, Skippe had developed an interest in and produced woodcuts of Old Masters, together with landscapes and later a few portraits. He had an interest in selling his Italian purchases even then and sold some at Christie's in the late eighteenth century. He owned more than one hundred paintings, as well as many drawings, most of which were of Venice and all of which were carefully catalogued.

Many were misattributed, however, and the last one was sold at Christie's in about 1990.

Whilst on his travels, Skippe made a number of drawings on sites such as the Eremitani Church in Padua, where he copied, amongst others, Mantegna's fresco cycle. The British Museum has a collection of Skippe's work and his Old Master-style drawings have even sold as originals in the past and are not without merit.

Skippe then moved to Overbury in Worcestershire to be near his sister Penelope, who had married James Martin in 1774, and he remained there until his death in 1812 when he left the bulk of his assets to the Martin children, having had none of his own. One of these was John, who married Frances Stone and who inherited most of the Skippe art collection and properties.

The Last Supper was purchased by John Skippe in Venice in the autumn of 1775. He sent it to Rome via Ancona (to an art adviser, dealer and banker to the English named Thomas Jenkins), describing it in a letter: 'A most capital and well-preserved picture by Titian. His name and date of the year are upon it. This picture was commissioned by one of the suppressed convents in the Venetian States. I purchased it in Venice in the year 1775.' It is recorded that he bought it from the da Mula Family (an extremely wealthy family whose history can be traced back to the thirteenth century and who had palazzos in Venice and Murano, the latter painted by Claude Monet, amongst other artists).

We have been unable to find positive documentation on the actual suppressed convent but it seems logical to assume that it was one which the da Mula family supported. The only reference to the da Mulas engaged in such patronage is the rebuilding of San Giacomo dall'Orio in 1225, together with the Badoer family. This premise is strengthened by the fact that the church still contains important artworks and, particularly, a set of paintings by Palma il Giovane, one of which is dated 1575. This was the year prior to Titian's death. Palma was in Titian's studio in 1576/7 and I believe he worked on part of the Ledbury *Last Supper*. The connection could be serendipitous but there are strong indications that this is the source of our painting.

On Murano we also find Santa Maria degli Angeli, another suppressed convent noted for the inclusion of young nuns from wealthy and prestigious Venetian families. Again, we find work by Palma il Giovane, as well as Pordenone, Giuseppe Porta and others and, moreover, the da Mulas had another palazzo on Murano. We find, then, a further set of indications as to a possible source although since no later documentation has yet to be discovered on either convent I feel my hypothesis of San Giacomo dall'Orio to be entirely reasonable.

Skippe said he had paid 50 zecchins for *The Last Supper* and asked Thomas Jenkins to sell it at 700 zecchins (he intended this as 'zecchinos', the name used after ducats in 1543). The painting did not sell and was shipped back to Ledbury, where it hung in the drawing room at Upper Hall.

During the recent restoration a small handwritten label bearing the name GELDESTON HALL, Norfolk was found on the

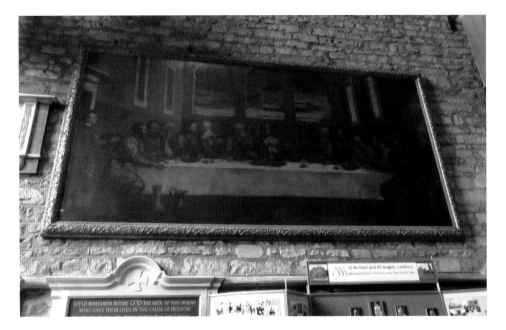

FIG. 1.1
The Last Supper
in situ, Ledbury

stretcher. A letter exists, dated 16 March 1909, which was sent by Waldyve Martin from Geldeston Hall in East Anglia, but why it was moved there is uncertain – if indeed it did go. However, on 27 May 1909 it was gifted to St Michael's Church in Ledbury.

Waldyve was the great-grandson of James and Penelope Martin, and his father John Martin (1805–80), was the senior partner at Martin's Bank. This was a banking partnership which had been started in about 1563 by Sir Thomas Gresham, the famous banker during the late Tudor period. The first Martin to join the bank was Thomas, in 1699. Two brothers of his joined the business, which continued for a further six generations, evolving into Martins Bank Ltd, before a series of mergers took place after the First World War. The bank finally merged into Barclays Bank Ltd in 1969.

Major auction houses have looked at *The Last Supper* four times since its arrival at the church, some in recent years, but there has been no conclusion as to who painted it.

CONDITION

The Last Supper has hung in St Michael's since 1909, having been restored *c.* 1800. The stretcher is English, made around that time,

and the heavy layer of old, yellowed copal varnish suggests a similar date. By the time I received the painting for restoration in 2018, there was some flaking, many scratches, abrasions and paint loss, especially in the lower left corner around the legs of the serving boy and to the water container and ewer. There are a number of changes in the details, creating several pentimenti, and one large change around the pentimento head to the left. These changes and their great importance in determining attribution will be considered in depth later.

In 1914 Henry Peerless visited the church, saw the painting and alleged that a vicar had folded the canvas double and put it in his attic. We have no further documentation on this. What is certain is that the varied travels of the painting would not have helped its condition and it would seem that the damage occurred long after Martin donated it to the church.

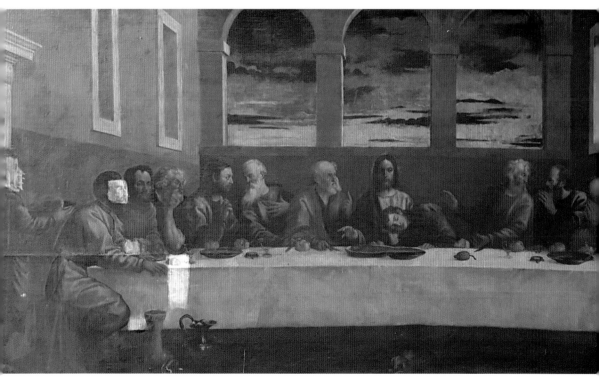

FIG. 1.2
The start of the
cleaning process

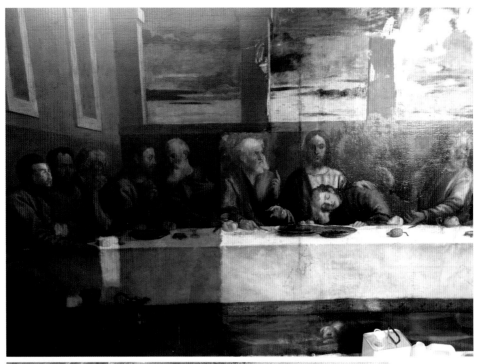

(Above)
Fig. 1.3
The removal of
the yellowed old
copal varnish

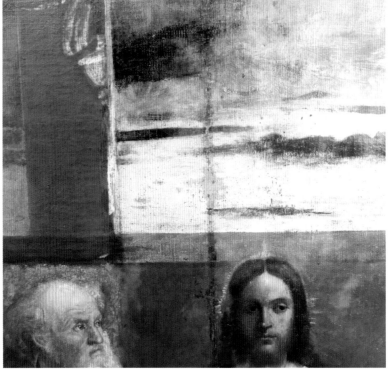

Fig. 1.4
Damage found
after varnish was
removed

(Opposite, top)
Fig. 1.5
Damage found
bottom left of
the painting

(Opposite, bottom)
Fig. 1.6
Damage
around the jug

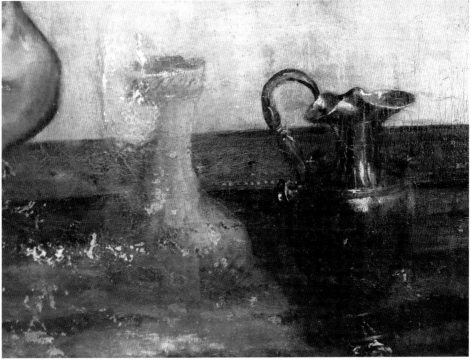

2

INTRODUCTION AND THE PROBLEMS WITH TITIAN'S WORKSHOP

The following study is an examination of the Ledbury *Last Supper*, an oil painting on lined canvas measuring 1.72 x 3.82 m in 1775 and reduced by 1 inch in lining around 1800, which was painted in Titian's workshop *c.* 1560–80. It was originally perhaps around 24 inches wider and 24 inches taller. It is not possible to know the precise size but clearly a large reduction has been made.

There are many aspects which make any Titian-related study extremely complex, including the huge numbers of replicas and variants, and the little known movement between Venetian workshops whereby outside artists would collaborate, although only for short periods. Drawings are generally also a source of important information, yet despite Titian's enormous oeuvre there are relatively few drawings, particularly those relating to his paintings.

Harold Wethey's important work, *Titian and His Drawings*, illustrates only some 120-plus autograph works,[1] together with many related drawings. Documentation is very limited, although Lionello Puppi's major study of Titian's letters has clarified some aspects of the workshop (bottega). No cartoons exist, but given their fragility, this is not surprising.

Then, in addition to a few permanent assistants, there were foreign visitors to the bottega until after 1560 when the firm became more family-based. Titian was long-lived and became a court painter of unparalleled success in Europe, and so required an extremely able and well-organised workshop.

Such was the demand for Titian's work that he became highly

skilled in market strategy and the vast amount of variants – many slightly changed with subtle variations and variable treatment in brushwork – are the result of a group of trusted collaborators, often with Titian's hand involved. This subject is in itself a major study and has been addressed by several scholars, but the huge amount of research – much still inconclusive – indicates the extent of the problem of identifying various hands involved in a large work like the Ledbury *Last Supper*. Dates become crucial, given that there was so much change within the workshop. As Giorgio Tagliaferro points out in his important study, *Le Botteghe di Tiziano*, 'it is extremely difficult to identify the actual contribution of these collaborators'.[2] We do, however, have documentation as to who was in the workshop much of the time, and clearly the vast Titian production required a reliable and consistent band of collaborators.

As to whether Titian himself actually worked on *The Last Supper* we shall consider later. Similarly, while we will look at the complexities of distinguishing master from collaborator, and which sections were those on which the collaborator worked – whether the initial drawing, laying in of ground colours or even upper layers of paint and glazes at times – this is not particularly relevant in our painting. I believe Titian's contribution was very limited at most and this is not one of his more typical workshop paintings where the small group painted much of the basics before Titian obtained a homogeneous finish by working over much of the surface so that it might be seen as an autograph work. To clarify, this aspect of Titian's workshop painting still requires considerable research, which would have to involve technical examinations of the paintings together with similar technical examinations of the work of possible collaborators. At this time this has not yet been attempted, although major galleries such as the National Gallery, London have exhaustively studied autograph works by the master.

As we stated, this is a vital aspect of Titian's work and we have only touched on it briefly, but its relevance for the Ledbury *Last Supper* is that the painting lacks consistency of style and close examination clearly indicates several hands involved using different brushwork, underpaint and abilities.

We shall now look at the workshop assistants and collaborators

to consider those who were probably part of the process and to exclude those who could not have been involved. We will then examine the signatures and dates which we discovered more recently by microscopic examination under ultraviolet light.

It is not possible to know precisely why so many hands were involved in *The Last Supper*, nor why the commission took so long (although it was, indeed, common for Titian to have many such commissions and personal works at Biri Grande, his home, for a number years as more important European requests for portraits were made). It seems highly probable, in this case, that in addition to the pressure of work, the plague and death played a part. Francesco Vecellio, Titian's elder brother, died in 1560. Girolamo Dente (a trusted and important assistant of over thirty years) died in 1572, and although he is not documented in the workshop at that date he must have been a visiting collaborator in the early 1560s. Titian died in August 1576 and his son Orazio died a month later.

During Titian's later years a vast quantity of work was produced in his workshops, beginning with San Samuele, then Biri Grande and later a 'travelling shop' when he was abroad, especially in Augsburg where he spent some time. During his life Titian had a wide range of collaborators, as well as a semi-permanent group of assistants and a number of important painters who joined him. Their wide-ranging abilities indicate the way in which the studios worked, with specialists being brought in for portraits, landscapes, and so on. There is almost no information on the part each individual played in any given painting, although perhaps landscapes are easier to determine since they may be compared with other works a particular artist was known to have painted. We lack such a landscape, of course.

As is apparent, there is a need to clarify, classify and differentiate autograph, school and master with help from others – followers, variants, copies, etc. – as there is a similar need with the recognition of specific collaborators, also by technical analysis. As yet there is no complete work on the school, although *Le Botteghe di Tiziano* goes a long way in recognising the range of collaborators and the difficulties involved in identifying the work of each assistant or collaborator. Various scholars in the last century have attempted different approaches. Some, such as Jan Żarnowski

in 1938, concentrated on the collaboration of Girolamo Dente.[3] Other hypotheses subsequently include works by Roy Fischer, Michael Cole, Matteo Mancini, Bert W. Meijer and Miguel Falomir, all offering new interpretations, whilst Puppi's more recent study of letters and documents has shed further light.

Primary sources were Giorgio Vasari and Carlo Ridolfi, and then later Marco Boschini. Vasari and Ridolfi listed Titian's collaborators, whom we shall look at shortly.

Our *Last Supper* was completed in 1576, with small, later additions after Titian's death until 1580. After Titian and Orazio died, we find varied contradictory reports on possible collaborators. An example of the complexities of the collaborators and the need for the establishment of accurate dates lies with Emanuel Amberger.

Amberger was an important assistant to Titian, and his father Christoph was a friend of Titian's whom he met when staying in Augsburg in 1548, then again in 1550–51. He was a noted painter and is documented as being in the workshop before and after Titian's death, completing unfinished work with Valerio Zuccato, Marco Vecellio and Cesare Vecellio. Christoph died in 1562 and Amberger was recorded as being in Venice with Titian the following year and then again in 1572. Also accurately documented as being there in later 1576/7 is Palma il Giovane, then aged twenty-eight, who after Tintoretto's death became the most noted painter in Venice. Amberger seems to be a possibility for one of the heads in *The Last Supper* but there is almost no example of his work to be found for us to conduct a comparison, and this has included a direct search with museums in Augsburg and Munich. We have looked at tax returns in Germany and discovered that Amberger was still paying taxes until 1572, which suggests that he may have returned, but it is more likely that this related to his late father's studio, as Christoph was a prolific portrait painter.[4]

Further research proved that Marco Vecellio and Amberger were commissioned to produce cartographic drawings and models for the Magnifica Community and then in March 1570 Amberger signed a power of attorney drawn up at Biri Grande, in which the 'family' of the master is mentioned. Puppi suggested that this connection with the Vecellio family is probably what convinced him to remain at the Venetian Lagoon from 1565–95.

There is further evidence of Amberger producing a processional banner related to the workshop, indicating a continuity with it even after Titian's and Orazio's deaths.[5, 6]

So it seems we have documentary evidence of a major Titian collaborator and yet there is no example of his painting, nor has any part of a Titian painting been positively identified as Amberger's work. Documentation on most of the assistants is almost completely lacking at this time, together with technical analyses of their work. Here we find more references to dates but still no indication as to what Amberger actually did. The simple explanation for our inability to recognise his contribution is of course because all the best collaborators were doing their utmost to work in a style as near to that of Titian as possible. Furthermore, Titian would work over school paintings with his own brushwork to maintain the homogeneity essential for a successful painting.

It is interesting that Ridolfi and Vasari, the latter of whom knew Titian, both note the complexities of attributing the various studio collaborators.

Given our documentation on the source of *The Last Supper* and the reference to a signature and date, together with many models which indicate Titian's workshop (we shall investigate these later), we first have to ask who created the composition and then address the difficult problem of all the hands involved. In this situation one would normally look at the sources of the style and the working methods.

In Leonardo's *Last Supper* (1494–8, Santa Maria delle Grazie, Milan) and many other large-scale works, a certain procedure is followed from initial sketches – often from life – the varied combinations of groups and alternative compositions in sketches, the full-size cartoon, and then often a spolvero, pricked along the outlines and pounced with a bag of charcoal on to the prepared canvas. An alternative was a transfer completed by assistants from the cartoon. In fact, there is no evidence of a spolvero or black dots anywhere in the Ledbury *Last Supper*, so it seems possible that a simple transfer could have been used, but X-radiography would be needed to determine this. In fact, we shall look at this more closely later but there is much evidence of direct freehand drawing, some matching Titian's own style. X-rays would also show further underdrawing and changes over

the transfer and could possibly help identify a style. We certainly have changes in the composition; the many small pentimenti, the addition of the two boys and the removal of one boy's head, and the changes in several faces would only be made by a workshop master rather than an assistant, and as such are very important. Similarly, preparatory drawings would be very helpful but none exist, nor do we have a consistent style of painting whereby one could make comparisons. Perhaps three or four different hands worked on the faces and assistants certainly completed the draperies, architecture and table items. Moreover, the work was undoubtedly completed over almost two decades, which complicates attributions further.

To summarise, we have a number of painters working over many years and in all probability a year or more after Titian's death and some not necessarily of the Vecellio family who were the primary helpers at this point (Tintoretto and Amberger were also both recorded). We have different styles and brushwork, a wide range of abilities and no consistent modus operandi. Some pigments have subtle underpainting, others were directly applied in bold impasto, whilst certain faces have beautifully observed character and others are a little less well observed.

There was, by this time, a close-knit group who were adept at emulating Titian's style, and over the centuries this has caused many a Titian to be downgraded to a proposed assistant, some even in major galleries such as the Louvre where a 'Titian' is now classified as a Polidoro da Lanciano, an artist we shall examine carefully in due course. As we will observe, there were many intermittent collaborators who also had their own studios but were still able to work with Titian in a harmonious style.

The fact that our *Last Supper* is on a large scale inevitably means that a number of painters were involved in the workshop, but what is unusual is the disparity of styles. Even Vasari, who met Titian and his nephew, noted these problems of attribution (as we saw earlier) and little has greatly changed despite many scholarly studies on the subject.

Despite *The Last Supper* having arrived in England some two-and-a-half centuries ago and having hung in the church for over a century, it has remained a mysterious canvas. We believe we may now offer some solutions but, as has been shown, Titian's workshop

requires initial understanding. The usual positive method of identification, in addition to traditional connoisseurship, would be a full technical analysis from canvas type, drawings, pigment analyses, brush types and sizes and particularly X-radiographs of underdrawings. We have completed some of these examinations and whilst X-rays would reveal those vital underdrawings, we have no comparisons to make with collaborators, since no systematic methodological study of the underdrawings of Titian's school has yet been attempted.

Having now established the parameters of the Ledbury *Last Supper* and the problems of attribution, we shall examine Titian's workshop and study dates, techniques, styles and models.

1. Harold E. Wethey, *Titian and His Drawings*, Princeton, NJ: Princeton University Press, 1987.
2. G. Tagliaferro, B. Aikema, M. Mancini and A.J. Martin, *Le Botteghe di Tiziano*, Florence: Alinari, 2009.
3. Jan Żarnowski, *L'Atelier de Titian: Girolamo di Tiziano*, Paris: Lemberg, 1938.
4. Roy Fisher, 'Titian's Assistants during the Later Years' (PhD thesis, Harvard University, 1958), 1977.
5. Mattia Biffis and G. Tagliaferro, *Emanuel Amberger e I Battuti di Serravalle*, Venezia Cinquecento, XVII, 2007, pp. 77-102; Józef Grabski, 'The Contribution of Collaborators in Titian's Late Works', *Artibus et Historiae*, no. 67, vol. 34, 2013, pp. 285-310.
6. Lionello Puppi, *Su Tiziano*, Milan: Biblioteca d'Arte Skira, 2004; and many Tiziano/Puppi letters.

3

TITIAN'S
WORKSHOP

To understand the dynamics of Titian's workshop, Enrico Dal Pozzolo's description of the Titian 'solar system' is an excellent concept[1] and is explained later in the chapter.

In the mid to later years of the workshop, Titian had a huge workload with many assistants. There was little documentation on 'Le botteghe' – the several workshops which Titian had in Venice and Europe – although Tagliaferro, Aikema, Mancini and Martin have, perhaps, produced the best study to date. As mentioned in the previous chapter, Titian's first workshop was at San Samuele, after which he spent the rest of his life at Biri Grande in Venice. There were possibly others. He certainly took some artists with him when he travelled, and patronage extended to foreign courts as well as the noble Venetians.

Titian's shop was not an academy or school of art. It comprised a close group of collaborators with visiting and occasional helpers, some of whom were independent with their own workshops. Little is documented as to specific contributions but we do know that there was a network that was social, cultural and artistic, and that there were many visitors. Each assistant had his place in the shop with Titian at the centre of his 'solar system'. In addition, there were many other workshops throughout Venice using Titian's ideas and some of the other workshop masters were occasional visiting collaborators.

One of the functions of the workshop was the production of serial replicas, variants and copies. An archive catalogue would not have been merely sensible but essential, given the large numbers

of versions of Titian's work. Evidence of this is seen in the vast number of series paintings in existence. Documentary evidence lies in a Council of Trent letter sending Enrico Castelnuovo and Antonio Perez to choose from such versions.

Further positive evidence is the letter of 9 July 1549 from the Spanish ambassador to Philip (as yet prince, not king): 'As regards your Highness's instructions for sending the portraits, Titian has given me the first one which I am sending with this letter. Another two have been made from it, which in my opinion are not so fine although they are good and will be better after the final hand because Titian is refining them each day; and I believe they will be completely finished in a few days.'

More evidence is from the Duke of Mantua's agent in Venice, Benedetto Agnello, who reported a delay in February 1549. Titian had failed to send a portrait of the duke's wife, Catherine of Austria, since he was making another copy for Ferdinand, King of the Romans. Not all copies were produced immediately, which suggests that Titian used other forms of record or memory, and in some cases the copies were never completed.

It is clear that Titian did make copies and these were vital if a long period of time elapsed between the original and the copy. Miguel Falomir, Director of the Prado Museum, noted Paul Joannides' research on Titian's 'ricordi'. Not only was the practice of keeping records of economic value but it served to ensure a copy existed should a painting be lost en route (as happened with an *Entombment* in 1557, destined for Philip II). Joannides believes that Titian retained some sort of copy – whether a sketch, small finished painting or detailed drawing is unknown.

There is evidence of Titian retaining a systematic catalogue, since so many variants exist produced by the workshop from around 1545. It is logical that he kept drawings of large paintings and paintings of smaller works but few drawings exist and only one relates to a known painting. There is certainly evidence that Titian did retain drawings, as he mentions this himself on several occasions.

In this context we must accept that drawings and portrait heads once existed for the Ledbury painting, since the fifteen heads are all quite different and some are certainly portraits. The pure practicality of using small portraits would have been far

simpler than finding so many models at appropriate times as the painting developed.

Given that our extensive research has now established that this *Last Supper* is not a version or a copy but an original work, the very arduous task of examining Titian copies and variants is not relevant but it is an area which needs much closer examination in the future. Miguel Falomir has examined some of the Prado Titian using X-radiography and infra-red, which enabled a better understanding of Titian's methods. These forms of procedures are also needed for a better understanding of the plethora of workshop painters.

The workshop was divided between the Vecellio family with, initially, Tiziano Vecellio (*c.* 1490–1576); Francesco Vecellio, Titian's elder brother (*c.* 1475–1560) and then Orazio Vecellio (*c.* 1528–76); Marco Vecellio, Titian's nephew (1545–1611); and Cesare Vecellio, Titian's cousin (*c.* 1521–1601). There were then close collaborators (such as Girolamo Dente) and visiting helpers (including Polidoro da Lanciano, Parrasio Micheli, Simone Peterzano, Bernardino Licinio) and the permanent minor assistants about whom we lack almost completely any documentary evidence (for example, Giovanni Maria Verdizotti, Damiano Mazza, Sante Zago and Valerio Zuccato). In addition, there were the foreigners, Amberger, Christoph Schwarz and Lambert Sustris, but we shall look at all these shortly. Collaborators included major painters, such as Palma il Giovane, after Titian's death.

A study of all the minor painters is sadly lacking and, as we noted, since Vasari's time recognition of each has been impossible. The technical examination of each, even with X-radiographs as mentioned earlier, would probably still enable little progress since each was striving to work in total harmony with Titian and reproduce his style. All would have used the same available Venetian pigments prepared in the same manner by studio assistants. The composition would have been drawn-out directly with chalk, or from a cartoon by Titian or Francesco and then by Titian or Orazio after 1560, and transferred by assistants too, so little evidence to differentiate perhaps fifteen different painters would be obtainable. Once again, in Titian's bottega and in our *Last Supper* we are primarily reduced to a very careful stylistic comparison of brushwork and techniques.

The Titian 'solar system' concept emphasises the need for some form of classification, as is used in salerooms. Dal Pozzolo suggests 'autograph' (by Titian), 'attributed', 'workshop' (when produced in the shop with supervision), 'circle of' (during the period and influenced by Titian), 'follower' (when the style reflects Titian but not by a student/collaborator), 'manner of' (when out of period), 'copy' (when reproducing a known image) and 'false' (when attempting to be fraudulent). Given these possible forms of terminology, we may be certain that this *Last Supper* is 'workshop of Titian', although, as we shall see, Titian himself was involved in its creation.

There has been much scholarship over the past few decades especially and our understanding of Titian's botteghe and their organisation has increased considerably, together with research at the Fondazione Centro Studi Tiziano e Cadore which had produced many critical studies.[2] We know Titian's close associates, since many were named by Vasari, Ridolfi and Boschini. However, all the scholars who have studied the workshops from the sixteenth century to the present day agree that the problems of recognising individual artists needs to be further clarified and that with few exceptions, such as Francesco Vecellio and sometimes Dente or Polidoro, this is, in fact, generally not possible.

That, then, will be the subject of this study: an attentive analysis of all the known artists in Titian's shop to determine those whose dates might suggest possible involvement, particularly considering those whose techniques might be in accord with *The Last Supper*, since we have that rare school painting, one involving several artists with different styles and less attempt at harmonisation than one would expect. Moreover, this large-scale painting has been neither recognised nor researched until now.

1. E.M. Dal Pozzolo, 'La "bottega" di Tiziano: sistema solare e buco nero', Studi Tizianeschi, IV, 2006, pp. 53-98.

2. Fondazione Centro Studi Tiziano e Cadore. Pieve de Cadore.

4

THE WORKSHOP ARTISTS

The earliest information we have on the workshop artists is from Vasari, who knew Titian and met various artists in the workshop. He lists Girolamo Dente, Paris Bordone, the Germans Schwarz and Amberger, together with Francesco Vecellio, Titian's elder brother. Carlo Ridolfi (1594–1658) was a biographer and artist who lived after Titian. He names Orazio Vecellio, the three students – Nadolino from Murano, Damiano Mazza and Lorenzino – then Christoforo Suarz (Schwarz), Polidoro da Lanciano, Sante Zago, Giovanni Maria Verdizotti, Simone Peterzano, Marco Vecellio, Paris Bordone, Emmanello Tedeschi (Emanuel Amberger), Parrasio Michiel (Micheli), El Greco, Valerio Zuccato, Domenico Mancini and Bernardino Licinio. Ridolfi concluded that Bordone and Mazza were the most documented in the workshop. He further notes that Nadolino worked mainly from Murano, selling portraits and private devotional paintings, and that 'the students left early before developing their talents'. He talks of Dente as 'Girolamo di Tiziano' and was unaware of the extent of his work in the shop. We shall discuss Dente in greater detail later, since he was in the workshop for around thirty years as well as having an independent studio.

THE FOREIGNERS

Ridolfi then tells us that Lambert Sustris was primarily a landscape painter but produced some excellent portraits. He also worked in Tintoretto's studio.

Ridolfi's knowledge of Emanuel Amberger, the son of a noted portrait painter, was limited, but he is documented as working with Titian in 1568 as a 'favoured assistant'. He joined Titian's workshop in 1562, after the death of Christoph, his father. Niccolo Stoppio wrote to Hans J. Fugger in 1568 regarding Amberger's part in the workshop, stating that Titian thought him 'an excellent man. He does for him the most possible. He later adds some touch and sells like his own hand.'[1] Amberger met Titian in Augsburg during one of his visits, but we can identify his work in several Titian paintings, such as Jacopo Strada, and his self-portrait is probably that of the figure to the left in *Religion Succoured by Spain*, which had been promised to Philip II in 1568. After Titian's death in 1576, his son Pomponio was still paying Amberger and Marco Vecellio – Titian's nephew – presumably to complete work begun by the master, which proves that Amberger was in the workshop *c.* 1576–8.

Ridolfi only knew of Polidoro da Lanciano as a painter of small devotional pictures, whilst in fact his *Washing of the Feet* (1540s) is 126 x 223 cm and we have documentation of him painting frescoes (now lost). Ridolfi discusses Marco Vecellio's portraits at some length and believed Bordone and Parrasio to be close associates of Titian.

Jan Stephan van Calcar was close to Titian in age and in two portraits we can see a Titianesque style, *Portrait of a Man Holding a Book* and the *Portrait of a Young Bearded Gentleman*. He would have been seen as a highly skilled specialist collaborator. His known portraits may well relate in quality to our two *Last Supper* portraits but he died in 1546, about fourteen years before our *Last Supper* was begun. To include him as a possible assistant in our painting would mean having to rethink the date of the initial conception of our picture, although it was not uncommon for Titian to retain paintings for many years. The National Gallery, London's *Vendramin Family*, for example, was in the studio for sixteen years.[2]

When Lambert Sustris arrived in Venice, he was already an established painter, having probably been trained by Jan van Scorel (discussed by Ballarin, Dacos and Meijer)[3] and several works show a direct influence of Titian in terms of compositions (for example, his *Reclining Venus* of *c.* 1540–60) in Amsterdam and we know he accompanied Titian abroad in 1548 and 1552. He had

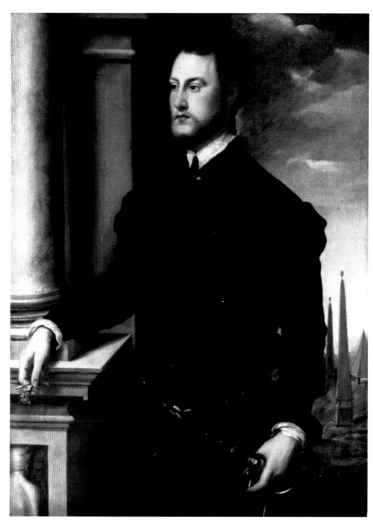

FIG. 4.1
Jan Stephan
van Calcar
*Portrait of a Young
Bearded Gentleman*
oil on canvas
125 x 92 cm
Private collection

his own workshop, contributed to Titian's landscapes and also collaborated with Veronese on the fresco cycle in Villa Giunti at Magnadola, together with Christoph Schwarz. We do not know precisely to what extent Paolo Caliari or his brother Benedetto were involved in the frescoes, nor whether the considerable sections completed by Schwarz were completed before, during or after the Veronese sections. It seems likely that the work was all completed at the same time and Schwarz would surely have viewed the completion of such a major decorative project.[4]

Schwarz arrived in the Veneto in 1570 and worked with Titian, returning to Germany in 1573. His own work does not

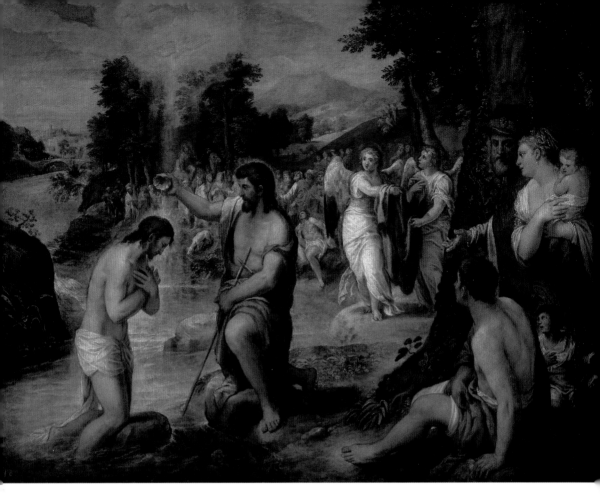

particularly appear Titianesque and he is another example of
Dal Pozzolo's 'solar system'. Schwarz (1545–92) was a German
court painter, and he probably came to Venice at the same time
as Sustris, since Schwarz worked in Augsburg and would have
known Sustris there. The work of the two painters is sometimes
confused. We shall consider the Veronesian influences on our *Last
Supper* and we have to wonder whether some came via Schwarz.
I would postulate the idea that he could briefly have returned to
Titian, having been exposed to the influence of Veronese and at
least suggested a number of Veronesian features.[5]

This further detour from the Ledbury *Last Supper* may seem
tortuous but Schwarz was a highly regarded German artist who
we know was in Titian's shop at the same time as our canvas.

Lambert Sustris had joined Titian's shop in the late 1530s,
and after returning to Augsburg he came back to Venice. He
was much influenced by Raphael, Venetian forms, colour and
techniques and Tintoretto. He would also have absorbed the

FIG. 4.2
Christoph Schwarz
Baptism of Christ
oil on panel
1575–80
125 x 165 cm
Prado Museum,
Madrid

huge Caliari influence whilst he worked on the Villa Giunti frescoes at Magnadola with Schwarz and the Caliari brothers, and would have discussed it on his return. This is supposition to some extent, lacking documentation, but surely inevitable and changes were made later in the *Last Supper*'s creation.

Sustris travelled with Titian in 1548 and 1552 before returning to Venice where he was then influenced by Francesca Schiavone and Parmigianino. It seems highly likely that he would have returned to the workshop at some point, even if as a visiting collaborator, although he had his own studio. At this point

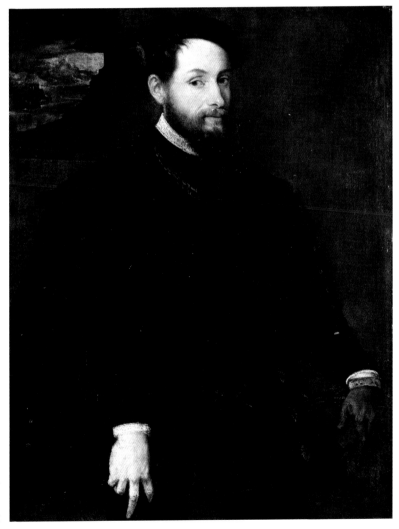

Fig. 4.3
Lambert Sustris
Portrait of a Man
1535–68
oil on canvas
120.7 x 92.7 cm
The Jules Bache
Collection,
New York

The Last Supper was in Titian's bottega and Sustris could have discussed it, worked on it or suggested the changes, as could have Schwarz, who left for Germany by 1573.

The eighteenth century provides even more lists of collaborators and whilst Marco Boschini in the seventeenth century is quite helpful, it was not until the nineteenth century that scholars added to our knowledge. In the last century yet more scholars examined different aspects of the workshop, together with studies on individual painters.

This further diversion may still seem somewhat irrelevant to our *Last Supper* but the purpose is to indicate the extreme complexity of the workshop in the late 1550s to 1576, and to further contemplate those painters who we can place in the workshop at that time and who had an appropriate style, ability and position. Much of the research on the workshop relates to Titian's earlier work and is outside the scope of this study, but as research progressed and even more students, assistants and collaborators were identified – by name at least – some with possible attributions, these attributions were often reattributed by later scholars. This situation continues today. Some of the studio whom we know were there later arc not necessarily in our immediate field of study for often stylistic reasons, but this outline of Titian's workshop perhaps indicates how little may be taken for granted. Opinions change, documents are re-examined or discovered and earlier theories are re-tested as new source material is found. A major problem is that this was the height of the plague and much was not documented and signatures were sparse, lost or badly damaged – as is the case surrounding our *Last Supper*. Other documents refer to paintings which cannot be confidently identified, some painters are names without paintings and much, even today, is opinion, hypothesis and conclusions based on paintings which are only loosely attributed and, of course, very rarely signed.

PARRASIO MICHIEL AND GIAN PAOLO PACE

A further possible Veronesian source is that of Parrasio Michiel (Micheli) who died in 1576, the same year as Titian and Orazio. He was a friend of Titian's, was well-educated and had a network of

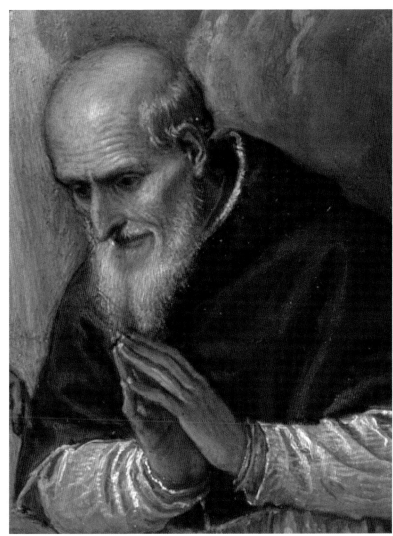

FIG. 4.4
Parrasio Micheli
Pope Pius V (detail)
1567
oil, copper
plate support
42 x 30 cm
Prado Museum,
Madrid

intellectual friends. His work shows connections with Veronese, with whom he was in contact prior to Titian. Much is very finely executed, particularly his portraits, but *Pope Pius V* (1567, Prado Museum) has distinct similarities to some of our apostles with bold but well-handled impasto paint and mainly earth pigments in the flesh tones.

Parrasio later befriended Veronese, who gave him drawings and compositional ideas. Given his friendship with Titian, we also have to accept that he could have returned briefly as a collaborator, bringing his new ideas (he would surely have

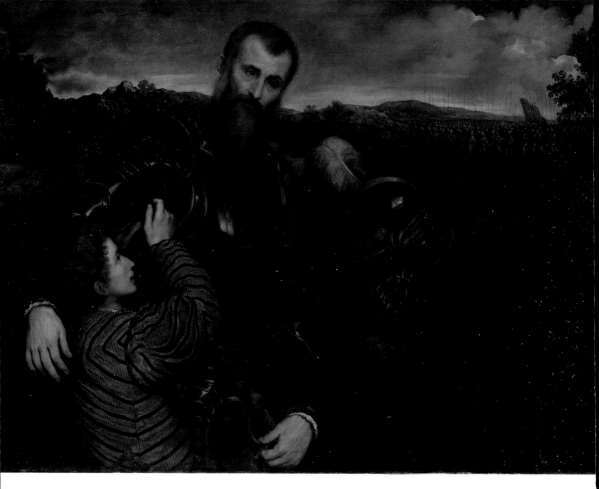

known the 1560/61 Villa Barbaro pictures at Maser, which we shall see later is one probable source for the two servant boys in the Ledbury *Last Supper* doorways). His Montefeltro Chapel paintings show an artist capable of handling complex figure compositions and boldly executed heads with a certain freedom. However, there appears to be no documented evidence of Parrasio actually working with Titian at this time, so his contribution is somewhat speculative.[6]

Paris Bordone was, as we have seen, listed as being an important collaborator, but having completed a technical analysis of one of his heads of Christ painted in 1545, my feeling is that his style is finer and therefore inconsistent with any part of our apostles.

The limited knowledge, minimal documentation and lack of paintings belonging to Gian Paolo Pace does not merit our study, although he may well have worked in the bottega in Venice up to around 1560.

FIG. 4.5
Paris Bordone
Portrait of a Gentleman in Armour with Two Pages
1520–71
oil on canvas
116.8 x 157.5 cm
Metropolitan Museum of Art, New York

SIMONE PETERZANO

Born in the mid-1530s (Miller discovered a deed recording his death in 1599) and probably in Venice from the 1560s, Simone Peterzano was Caravaggio's master. He was a highly accomplished late Mannerist painter and some of his work shows a debt to Veronese and Titian. I do not, however, believe Peterzano's subtlety of brushwork appears in our *Last Supper*, yet there are instances in his attributed work of holy family images which recall Polidoro's Joseph. There are also Titianesque references in his work. In fact, much is known of Peterzano but there are

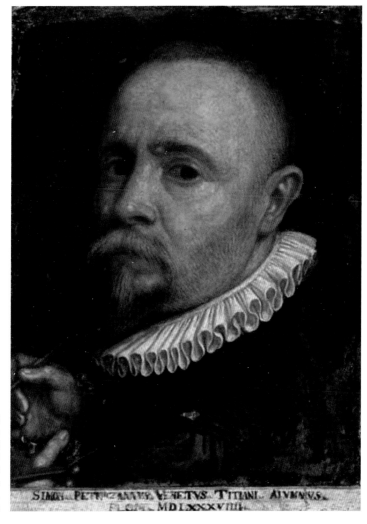

FIG. 4.6
Simone Peterzano
Self-portrait
1589
oil on panel
23 x 16.5 cm
Private collection,
Rome

limited references to Titian's studio, although he does seem to have been involved. In 2006 and 2012 Enrico Dal Pozzolo wrote on the confusion of attributions around Parrasio, Dente and Peterzano, and of course this is precisely the area which we are investigating, but this does tend to link Parrasio to Titian's workshop. Scholars have differed on the intricacies of Titian's workshop for many years. An example is the *Venus and Cupid with Two Satyrs in a Landscape* (1570–73, Pinacoteca di Brera), which uses the Salome figure that Dal Pozzolo considered as possibly by Peterzano but now places it with the band of occasional collaborators in which hired artists for specific clients were found (Buxei, Ludovico di Giovanni, Gregorio, Bartolomeo, Cristoforo and Stefano Rosa). He also includes Paris Bordone, Parrasio Michiel, Damiano Mazza, Simone Peterzano and El Greco amongst the already large number of collaborators.[7]

Peterzano's hand, therefore, probably does not appear, although much is known about him, but this diversion does indicate the vast number of possibilities for our *Last Supper*.

COLLABORATORS AND SIGNATURES

We do, therefore, find much interaction between Titian's collaborators. The question is: were paintings produced within or outside the studio? That is to say, if we encounter a Titian-style painting with clear influences and similarities of style, was it produced by an assistant working for Titian – thereby being a workshop piece – or was it produced independently by the artist in his own studio but greatly under Titian's influence? Workshop paintings were frequently retouched by Titian and all the painters we have encountered could not have worked at Biri Grande simultaneously. We know Girolamo Dente worked independently as well as closely with Titian, as did a number of others – perhaps many – but the long list of little-known assistants are names without pictures. We have scant idea what they painted independently.

It is now becoming increasing apparent that while it is popularly thought that Titian had a huge band of assistants, he had, in fact, a small group of collaborators, some of whom were family while other artists would join him for a period, at

appropriate points, depending on their specialisation. Titian clearly used certain artists for specific paintings and most were of recognised ability – including some of those we have looked at already – as they would sign the workshop paintings with their own name together with that of Titian (for example, Girolamo Tiziano). This occurred in the Ledbury *Last Supper* and we shall consider it later. Some also continued to sign in this manner even when far beyond Titian's bottega by way of indicating their prestigious background.

At this point in the research of the Ledbury *Last Supper* it became apparent that the documentation of dates was crucial for each potential collaborator. Certain artists seemed probable assistants until it was discovered that they were not documented as being in the workshop, had died or their style was incompatible with the date they would have worked there.

We shall now look at what I believe are two of the most important names in relation to our *Last Supper*: Girolamo Dente and Polidoro da Lanciano.

GIROLAMO DENTE

As with almost all Titian's collaborators, Dente's role is not precisely known, but he is of great significance to our *Last Supper* since we know he was with Titian for around thirty years and during our research we discovered his monogram on the painting. Vasari tells us that Dente helped Titian in many works, was a disciple and knew him as Girolamo di Tiziano. Ortensio Lando, the philosopher and writer (who died in 1560) knew him as 'Girolamo Dente da Cenede, a disciple of Tiziano da Cadore'.

Dente signed *The Four Seasons* (*Le Quattro Stagioni*) painting (Haldane Fine Art, London) HIE.MO.D.TITIANI N21. He also signed HIE.MO on an altarpiece in the Gallerie dell'Accademia Venice and we shall look closely at this when discussing signatures. There is some documentation and a few positively attributed paintings, and he probably joined Titian's botteghe in the 1520s, remaining for some three decades and almost certainly acting as a visiting collaborator later. There is information on this, including a 1564 letter from the Spanish secretary in Venice to Perez, Philip II's secretary, where we learn of Dente staying

with Titian for thirty years.[8] He also witnessed Titian and Cecilia's wedding in 1525, celebrated by Dente's brother Paolo.

As we shall see, Titian's brother Francesco was a collaborator, but as he was more involved in business Dente took his place in the workshop when Francesco moved to Pieve di Cadore to organise the family's timber and land business.

The number of works which may be safely attributed to Dente commence with *The Four Seasons*, a 1559 *Madonna and Child with Saints* in the Venice Gallerie dell'Accademia signed HIER.MO and a portrait of the Doge Lorenzo Priuli, which was 'given to Maistro Girolamo Tuciano dipintor'. This is dated 1560, after the doge

Fig. 4.7
Girolamo Dente
Le Quattro Stagioni
(*The Four Seasons*)
1543–6
oil on canvas
168 x 181 cm
© Haldane Fine
Art, London

had died the previous year on 17 August 1559. An altarpiece of Sant'Andrea between *Saints Sebastiano and Rocco* (1543, Cattedrale di Santa Maria Assunta, Vittorio) follows, and then the large *Annunciation* of 1557–61 (Gallerie dell'Accademia Venice) which includes many portraits, also in Venice. In London's National Gallery, Nicholas Penny determined that he saw Dente's hand in the three boys on the left in the *Vendramin Family*; this is now an accepted attribution and Fisher had remarked similarly. The face of Gabriel, with its free brushwork, is quite different from that of the three boys. We shall look at this again with reference to the portrait of Marco Vecellio in Titian's *Allegory of Prudence*, also at the National Gallery.

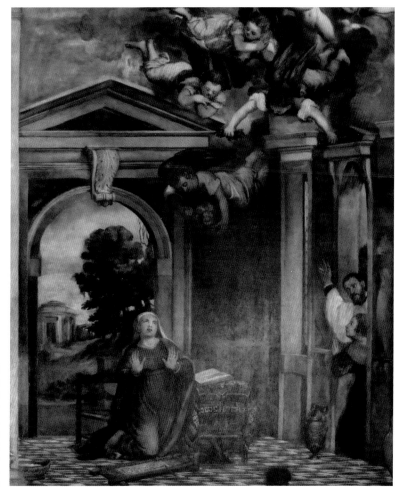

FIG. 4.8
Girolamo Dente
Annunciation
(detail)
1557–61
oil on canvas
345 x 600 cm
Gallerie
dell'Accademia,
Venice

The two paintings of Santa Caterina and Santa Veneranda, once thought to be by Salviati, are generally considered to be by Dente and the last identifiable signed painting is from 1564, an image of the Virgin and from the church of Sant'Elpidio a Mare. It is signed HIER D.TICIAN.

Returning to Dente's *Annunciation*, we see vital evidence in relation to our *Last Supper*. *The Annunciation* is 345 x 600 cm. The doorway mouldings are very similar to those in the Ledbury *Last Supper* – in fact they are almost identical – and the light shines through them at the same angle. Additionally, figures emerge through the central door on the right, reminiscent of the servant boys. It is tempting to attribute this model to Veronese's Villa Barbaro frescoes where we find a similar motif – however that was not completed until 1560/61 – and Dente's *Annunciation*

FIG. 4.9
Paolo Veronese
Sala a crociera,
Villa Barbaro
(villa di Maser)
frescoes, 1559–61

is of 1557–61, so it would seem that we have Dente reusing the 'figures through doorway' motifs in our *Last Supper*, which he saw worked well in his *Annunciation*. Around the head of the boy on the left is a narrow band of later retouching, probably *c.* 1800, which has changed the shape of his forehead. Dente died in 1572 but I believe the scheme to include the boys was his. We saw earlier that Schwarz could also have brought the Villa Barbaro motifs of doorways but it seems more probable that it was Dente's conception.

There is minimal information on Dente's skill as a portrait painter but the fact that he was given the chance to paint the doge suggests his work was highly considered. There are several other works still in dispute but for the purposes of attribution in our *Last Supper* I shall restrict observations to those paintings generally agreed on by art historians to be the work of Girolamo Dente.

The figure of winter in *The Four Seasons*, the reclining white-haired man, bears a strong relationship to four of our heads – the apostles with white beards. The source of the pose is

Michelangelo's carving of 'Day' on the right side of Giuliano de' Medici's tomb (finished in 1533) and whilst it is tempting to look at the many similar figures with outstretched hands and arms on Michelangelo's *Last Judgement*, I can find no specific model there.

However, in the Ledbury *Last Supper* the apostle fifth from the right, in pink, shows much the same facial features and may well be the same model. The tousled hair, falling forwards, is also unusual, appearing in both figures and the bold impasto brushwork with very limited use of glazes similarly recalls our apostle.

The allegory of the four seasons was a popular subject and Dente would have been aware of the range of possibilities. Even Cesare Vecellio painted a fresco of the subject and the version by Tintoretto is a totally dissimilar composition, but Dente ignored the more advanced Mannerist possibilities and designed a painting based on popular Renaissance pagan gods and mythological symbolism. This is another example of his conventional approach to compositions which could have readily moved into original Mannerist ideas.

There is also a *Holy Family* which was for sale at Bertolami Fine Arts, attributed to Dente (66.5 x 58.7 cm) and although it is not in the accepted group of attributed works, in my opinion the head of Joseph recalls several Dente heads, together with four of our disciples. There is a similar use of earth pigments, strong confident impasto brushwork, a build-up of white highlights on the beard and highly competent modelling of form. The drapery modelling is much like that on our *Last Supper*. It has to be said that a somewhat similar form of brushwork may be seen on early Polidoro da Lanciano figures of Joseph, although with less subtlety. Many attributions have changed between Dente and Polidoro, not to say between Titian and Dente.

The problem with recognising Dente's 'style' is that he had become adept at working close to the style of Titian, emulating his technique or working to a specific requirement from him. In addition, we are looking at work spread over three or more decades.

One unknown aspect of Dente is the extent to which he worked with Titian while working independently at a similar time. His work has been criticised in the past but as Dal Pozzolo notes, his

Dresden Gallery *Sacra Conversazione* contains two portraits – and it had been previously attributed to Titian. This is further evidence that Dente was highly capable in portraiture, which is particularly relevant to our *Last Supper.*

Girolamo Dente was also proposed as a copyist for an altarpiece by Garcia Hernandez, secretary to the Spanish Ambassador in Venice, who informed Philip II that Titian had eventually agreed to paint a second version of the *Martyrdom of St Lawrence* for El Escorial on the canvas, where it remains to this day. This would not have been suggested unless he was deemed to be sufficiently competent, although at this time there were others in the botteghe who were probably far more able. The letter is dated 1564, so it seems likely that Dente was still collaborating with Titian, as the latter would not have countenanced his working alone and he may have established a studio at this time. In fact, Titian intervened, characteristically jealous of Dente and wanting to have a more exclusive relationship with Philip II.[9] This again indicates that Titian fully appreciated Dente's ability.

Dente's *St Sebastian and St Rocco* (1543, Cattedrale di Santa Maria Assunta, Vittorio) shares a very similar floor tile pattern to the one in the Ledbury painting and the face of the donor is painted with remarkable sensitivity.

The significance of this complex problem for our *Last Supper* was succinctly addressed by Jan Żarnowski in 1938. In one of his papers he was primarily interested in Girolamo Dente, and long before more recent scholars began to establish a body of work, Żarnowski had assessed the methodology which Titian used in his shop. This is of much significance for our own research. Prior to Żarnowski, Dente was considered of little interest, but given the positive identification as the painter of *The Four Seasons*, together with the authenticated fact of his collaboration with Titian, Żarnowski made a careful analysis of the painting which is also of considerable importance in our work.

Żarnowski postulated that the students were not limited to preparatory work but contributed to the actual work on the painting. He commented that in Titian's early stages, the master tended to work over every painting with glazes and detail to give it a homogeneous feel, but that this tendency reduced over the years so that individual hands could be recognised (this is still,

however, almost impossible in most cases). Żarnowski then noted that Titian used to ignore reference to his collaborators and the suggestion was that all work produced in the botteghe was his own. He also criticised the modelling and borrowings in *The Four Seasons*, although personally I see little detrimental in the latter; he used Michelangelo's sculpture of 'Day' from Giuliano de' Medici's tomb and a Titian Venus, both typical of borrowings throughout the Renaissance. Żarnowski attributed the lack of volume in the figures to Dente's lack of experience in the completion of paintings. He was presumably referring to the reclining figure of 'Winter' where little positive lighting has flattened the forms somewhat, but whilst I have not examined the work personally I do wonder if thin glazes in shadows have been lost in old restorations. This is certainly the case in the Ledbury painting.[10]

Żarnowski concluded that Dente was used to merely painting a 'neutral base', as Tagliaferro calls it.[11] The scholar also states that this is a hasty assumption and that National Gallery technical examinations have now proved that Titian did use such a process whereby he could work up final glazes using the basis produced by Dente or another collaborator. I assume Tagliaferro is suggesting that Dente once placed glazes on his figure to create more volume. I suspect a technical examination of *The Four Seasons* would reveal traces of lost glazes.[12]

Roy Fisher analysed several Titian paintings and noted on Dente's hand. He also observed that same change from Titian's early work when collaborators and their contributions were submerged.[13]

We now begin to find collaborators signing paintings and some other hands becoming apparent.

Tagliaferro has compared several groups of paintings attributable to Dente but many are Holy Families and Sacra Conversaziones, and whilst some art historians have hypothesised on Dente's oeuvre, no *Last Supper*, *Supper at Emmaus* or a comparable composition relating to male figures has been identified. Tagliaferro also observes, as did Żarnowski, that it is still very difficult – or impossible at present – to determine the degree to which Dente or others collaborated. Also, it is often clear that another hand was involved.

What is now apparent is the fact that a group of painters worked in close contact with Titian. This group certainly involved the family and Girolamo Dente, who, after Francesco, was the primary collaborator in the workshop. We shall shortly examine the possibly identifiable work of Francesco, Orazio and Marco, and consider their feasible contributions to our *Last Supper*. They were all content to help create harmonious compositions and they provided stability in a workshop which was now inundated with projects. Other collaborators, including Polidoro, Sustris, Licinio, Calcar and Amberger, would help when required but their art was not immersed in Biri Grande.

We are now beginning to see various contributions but, as yet, most of these must be attributions and hypothetical. This is until technical examinations of all the potential collaborators' independent, autograph work can be compared with similar examinations in Titian's paintings where we suspect that collaborators have been involved.

How, then, does this closer survey of Girolamo Dente's work relate to the Ledbury *Last Supper*? As I stated, one can only offer theories, opinions and comparisons based largely on compositional and stylistic factors together with models, but especially a very close examination of evidence for a cartoon, a tracing or even direct drawing. Then ground, visible underpaint, pigments, brushwork and glazes require microscopic examination at the very least.

A further complication with Dente is firstly the limited number of positively accredited paintings, then the fact that they are dated around the fifth decade whereas our *Last Supper* was probably started in the late 1550s or early 1560s. Whilst *The Four Seasons* represents Dente at perhaps his best, by the 1560s he was older and was noted to be somewhat archaic in his compositions. The brushwork in 'Winter', the reclining man, has a directness and power very like some of our apostles, and by this later date we still find strong portraits and heads in his work.

Mannerism had developed by this time but there were still clients looking for artists who provided more nostalgia for the past and this is a vital point for our *Last Supper*. It was a form of composition used throughout the quattrocento and perfected by Leonardo da Vinci in Santa Maria delle Grazie. Our architectural

framework is similarly used to emphasise the composition, and the disposition of figures is, as we have seen, highly reminiscent of Leonardo's *Last Supper* some sixty years earlier.

So, we have a Venetian painting which is far from mainstream Mannerism, a painter noted for his easy pleasant commercial solutions, together with documentary and physical evidence that the Ledbury *Last Supper* originated in Titian's workshop.

The Monopoli Altarpiece in Venice, painted in the 1540s, has recently been correctly attributed to Dente by Claut and Lucco.[14] It is closely related to Lorenzo Lotto's 1542 San Felice Altarpiece, and like the Lotto and our *Last Supper* it is archaic in design and creates a feeling of nostalgia. This was clearly at the express wish of those who commissioned it and doubtless they chose Dente because he was known to create just such work.

In my final hypothesis for attributions, I will address which heads Dente may have painted, but given all the facts it is inconceivable that he was not involved.

Research on Girolamo Dente has evolved, but little is known of his brother, Sabaoth, who was sufficiently able to take over the fresco decoration of Pope Pius IV's loggia in the Vatican after Raphael's main collaborator, Giovanni da Udine, died. It seems likely that there was some interchange between Rome and Venice in this way, together with working on a large scale, and in 1543 Dente is documented as working as a set designer.

As we have seen, Dente's precise role in Biri Grande is still a matter for conjecture. There is also more recent work on the formation of an acceptable body of work by Dente, so we need not digress further on his oeuvre. It is significant, however, that he was producing relatively large-scale complex compositions from the 1540s onwards, often with references to Rome and the antique – as was Titian. (His late *Last Suppers* have Doric and Ionic columns, as have his *Suppers at Emmaus*, although his *Supper at Emmaus* of 1542–4 moved away from the horizontal table format used by Leonardo.) We now find a portrait format and possibly the first use of a diagonal table, which must have influenced the young Tintoretto. Moreover, the Tuscan/Roman manner was now present in Venice via other exponents such as Schiavone – who arrived in 1539 – and Giorgio Vasari. This dramatic new source has been extensively examined, so we do not need to specify details.

We now have to consider why our Ledbury *Last Supper* has reverted to an architectural background which is unique in its simplicity. Decorative detail is almost non-existent and the entire design strongly recalls that of Leonardo's *Last Supper*, with Christ centrally placed and vanishing points meeting on Christ Himself. (The Santa Maria delle Grazie one has a vanishing point on the forehead whilst ours is on His neck, a small pin hole remaining.) Similarly, there is no exaggerated Mannerist tendency in the drama of pose, gesture or lighting.

At the beginning of this work I noted on the fact that we have documentation stating a convent in Venice commissioned the painting. I would now suggest that this convent was, perhaps, one restricted to simple minimal decoration in its artefacts and consequently it commissioned a composition decidedly dated.

It is tempting, therefore, to consider Girolamo Dente as at least being instrumental in the creation and design of the Ledbury *Last Supper*. Titian would not, of course, have countenanced Dente producing such a large-scale work alone in the bottega, so it is highly likely that he was involved in the initial proposals with Dente. If the work was started prior to 1560, it is possible that Francesco Vecellio organised the cartoon/transfer with supervision from Titian himself, after which either or both artists drew out the composition or Titian did so alone after 1560. Francesco had taken over the running of the shop by now, but he died in 1560. There is, however, no evidence of a spolvero or transfer.

This does mean, of course, that rather than looking at Dente's autograph paintings of the 1540s–60s where we are considering models, sources of the style, iconography and composition, we are especially considering his contribution to our *Last Supper*, largely with regard to figures and heads. This indicates more concentration on brushwork, pigments, ground and underpaint.

I have conducted a technical analysis as far as possible on these points but ideally one would require a similar analysis of Dente's later work to make a comparison. No such analysis has been attempted to my knowledge, so one is using close observation, microscopic paint analysis, ultraviolet light and thoughtful conjecture to solve this problem.

An X-radiograph might be helpful if there were underdrawings of different styles. The many pentimenti and changes are also very

unusual for a workshop painting, all suggesting a possible lack of cartoon with instead a direct chalk and then brush drawing. The two portraits to the left actually show a bold, black, brushed outline on a thin area and similar lines in brush may be found throughout the painting. This underdrawing is consistent with others drawn by Titian.

It is highly unlikely that a collaborator such as Dente would have been given the task of drawing-out the whole composition, although I believe he contributed some ideas. He could well have transferred the drawing to the canvas, but there is no way of knowing this. It was a mechanical process only. We must look at the Vecellio family, therefore, especially Francesco and then Orazio and Marco, who were the primary collaborators as Titian became older.

Polidoro da Lanciano should now be considered.

POLIDORO DA LANCIANO

We now come to one of the last painters to have been a major collaborator outside the family, Polidoro da Lanciano.

Until recently, Polidoro has not been given the appreciation he is due and has been considered by many as merely a painter of devotional images. Vincenzo Mancini and other scholars have now identified a body of work, some of which demonstrates that Polidoro's critical assessments were misleading.[15] His later work indicates a full awareness of developments in the Lagoon and some affinity with Tintoretto.

Around 1540 some major influences arrived in Venice in the form of Francesco Salviati, Giuseppe Porta and Giorgio Vasari, bringing with them the Tuscan/Roman manner. Polidoro's only documented work is the *Descent of the Holy Spirit* (c. 1540–50) in the Accademia, and already we see his understanding of Titian together with a grasp of the newly introduced Central Italian Style.

Similarly, the Berlin *Washing of the Feet* of 1546 (now attributed by Alessandro Ballarin)[16] shows Polidoro already handling a large scale (126 x 223 cm) sacred, narrative scene of the type soon to be seen in Titian's work.

The subject of further influences on Venice is a subject in itself and has been addressed by many scholars. We need to note the

influence of Bonifazio Veronese in the 1530s and early 1540s, particularly, with regard to Polidoro. Bonifazio's Brera *Last Supper* of 1535/6 relates to Polidoro's *Washing of the Feet* (1545, Staatliche Museen Gemäldegalerie) in the use of lighting, windows and closed space, and the later Bonifazio *Last Supper* in Edinburgh (*c.* 1530–50), with its three openings, sky, symmetry and apostles at either end with an air of restrained drama suggest the Ledbury picture. There are also several figural types and poses that recall our *Last Supper*. Bonifazio died in 1553, so his work precedes our painting.

The *Washing of the Feet* shows a rhythmic sequence of movements around the figure of Christ. We see this same sequence of movement in Bonifazio's *Last Supper* in the use of the lateral and foreground figures. Titian's Escorial *Last Supper* dates from 1557 and we may see connections with our *Last Supper* in both paintings, although Bonifazio does use the three windows and sky.

This study is not the place for an analysis of Polidoro's development, which has been examined by Vincenzo Mancini and other scholars, and doubtless more works will be added to his oeuvre in time. However, we do need to appreciate Polidoro as an artist perfectly able to absorb many major influences – far more so than Dente – yet able to maintain his own expressive means as we consider his probable part in the Ledbury *Last Supper*.

Much of Polidoro's earlier work consists of Holy Families and small-scale work, and this has given rise to Polidoro being seen as only a small-scale, devotional subject painter, but there are also major compositions, such as the The Walpole Gallery, London, *Christ and the Adulteress*, *c.* 1550, while the 1545 Gallerie dell'Accademia *Descent of the Holy Spirit* is 276 x 195 cm. These alone show that Polidoro was quite capable of orchestrating a complex figure painting. The perceived scale of Polidoro's work is much challenged by looking at his correctly attributed paintings more carefully. He secured at least one large-scale contract to paint a processional banner, in opposition to Battista Franco. At this time it was an important commission.

We find a drawing of a girl in the Louvre, very probably intended for an unknown fresco. (Prior to Veronese, Giuseppe Porta, Schiavone and Tintoretto were involved in the decoration of external façades as well as interiors.) This seemingly insignificant

drawing is, in fact, highly inventive in not only being a complex figure in motion but one which emerges into our space from a door in the gloom with a suggested staircase. It is a form of dramatic spatial illusionism unknown in Polidoro's work as yet and Mancini has proposed that it was possibly suggested by an architect such as Sebastiano Serlio. It was soon to be seen in the work of Paolo Caliari (better known as Veronese) and Giovanni Battista Zelotti, and then in the 1560/61 Villa Barbaro frescos at Maser.

I had originally placed a probable completion date of the *Last Supper* based on the influence of the Villa Barbaro frescoes. However, later discoveries in a technical examination revealed proof of a later date. Polidoro may well have seen the Villa Barbaro paintings or discussed them with others but, of course, we also have Dente's figures in doorways before that date, in his *Annunciation*.

So, did Girolamo Dente suggest the changes in the Ledbury *Last Supper*? Did Polidoro, now aware of spatial illusionism, suggest the emerging figures? Both Dente and Polidoro had died before the painting was completed. Dente died in 1572, so it is

conceivable that he could have suggested the changes that were implemented four years later. Or Polidoro implemented the changes, but in 1565, and since this was around thirteen years before the completion, I believe this is unlikely.

After Polidoro's initial time in Titian's workshop (speculated upon by some scholars but recorded by several contemporaries) he would have developed his own bottega and clients, and was producing a high volume of work, probably helped by his son. We know he returned to the workshop around 1545 and whilst he was perhaps not involved in the late changes, I believe he was one of

FIG. 4.12
Polidoro da
Lanciano, *Woman
Holding Vase with
Two Children*
Drawing
20.5 x 12.5 cm
Department of
Graphic Art,
inv 10733,
Louvre Museum,
Paris

Titian's regular visiting collaborators and could even have been involved in the initial composition with Francesco and possibly Titian around 1560.

During the 1550s the lack of larger documented work would seem to verify early biographers and critics, and suggest that Polidoro was now primarily producing private devotional images. However, amongst these we find works such as the Berlin *Madonna and Child with St Peter Presenting the Donor, Simone Lando, c. 1550.*

By this time Polidoro had absorbed the teaching of Veronese with monumental forms and dramatic gestures. The powerful head of St Peter against a pale sky and the beautifully painted face of Lando perhaps show Polidoro at his best. The composition recalls Veronese's Giustiniani Altarpiece in many respects and is a surprising work, showing the painter's breadth of influences – Veronese, Titian, Salviati and Giuseppe Porta – together with a fine quality of drawing and brushwork. Polidoro absorbed

FIG. 4.13
Polidoro da Lanciano
Sacra famiglia con Donatore, (Madonna and Child with St Peter Presenting the Donor, Simone Lando) (detail)
c. 1550
oil on canvas
99 x 166 cm
Gemäldegalerie–Staatliche Museen zu Berlin

Fig. 4.14
Polidoro da
Lanciano,
Mort della Vergine
(Death of the Virgin)
mid-1500s
oil on wood
25 x 103.5 cm
painted surface
Cleveland
Museum of Art

Schiavone's work and his frowning St Joseph in the late Berlin *Circumcision* and the old man in the *Death of the Virgin* panel have echoes in our *Last Supper*'s third apostle from the right.

Our fourth apostle from the left may well be the same model as the head of Christ in *Washing of the Feet* and his clasped hands are in sufficiently the same style as several of Polidoro's works to suggest that he may also have painted these.

The group of late panels are possibly predellas (there are burn marks from candles) and form a curious contrast to Polidoro's earlier work, as he commences a new approach. The *Death of the Virgin* particularly shows less clarity in the figures and the brushstrokes are bold and rapid. Mancini notes on the lightness of touch, freshness and vivacity.[17] The composition is frieze-like with no perspective or illusion of space, with a tortured group of poses and varied faces all bound together by the dramatic light, recalling Tintoretto. (In fact, the panel was traditionally attributed to Robusti, amongst others.) This is quite unlike *Christ and the Adulteress* (*c.* 1550, Walpole Gallery, London), where the 'rhythm of agitated and articulated bodies'[18] creates its own tension.

The significance of this anomaly in Polidoro's work, although late, indicates his previously mentioned ability to absorb varied influences and consequently we find variations of style in his painting. This, of course, makes it even more difficult to assess his contribution to a painting, but there are still many comparable sections of our *Last Supper* where we may see his hand.

One of Polidoro's last works is a small but remarkably powerful

sacred story with eight figures in the Galleria Palatina, Firenze (*c.* 1565, Inv. 5864). Freely painted forms move in a dark atmospheric chiaroscuro in a panel once attributed to Schiavone's late works. A vibrant light flickers over the rhythm of the figures as they flow and connect emotionally, recalling Titian, and in this panel there is the realisation that Polidoro was now moving into a whole new field of pictorial expression.

Much more analysis of this extreme painting may be found, but we are considering our Titian collaborators in relation to the Ledbury *Last Supper*, and despite having only examined a few of Polidoro's paintings I hope to have dispelled the Polidoro cliché of small devotional panel paintings. Rather, we find a painter highly receptive to the powerful influences in Venice of the time and in his last highly creative work – on which future research may reveal more – we find a painter on the brink of an emerging new exciting style and by now, certainly, one far above the title of merely a workshop assistant. We shall later consider Polidoro again, together with this new understanding and in relation to our *Last Supper*.

The full understanding of Titian's workshop remains a field of study which still requires considerably more research despite the extensive scholarly works such as *Le Botteghe di Tiziano*. This vast subject can only be touched upon in our book and our concern here is to try to establish Polidoro's part in Titian's shop and the Ledbury *Last Supper*, together with the contributors.

There are many references to Titian in Polidoro's paintings. They are often not simply in the use of models but rather iconographic and formal absorptions that are yet to be precisely defined. Some certainly developed in Biri Grande and in Titian's earlier workshops, and some from external, independent painters, many of whom had a common source in Titian. However, the complexities of these interchanges is beyond our present scope: rather we must now consider Polidoro's connections with the Vecellio family.

It remains to be defined who precisely worked in Titian's workshop, when they did so and who was aware of Titian's developments and worked in his orbit. Documentation on all this is sadly lacking, so one can often only make comparisons and wonder if those common factors we see indicate an artist surely working in his botteghe.

For our own purposes we might compare Polidoro and Francesco Vecellio, and observe certain links. These exceed models reused and reversed and identical subject matter with recurring motifs. Rather, we find a compatibility and common sensitivity. We see many Titian prototypes, poses and faces in the numerous half-length Holy Families and Mystic Marriages, and some are specific borrowings. Tagliaferro et al cover this well and, as they point out, models are clearly coming from the Vecellio shop but they are often reused by Polidoro for his own purpose in a new composition. We are not viewing a copy or a version but a new work by a painter who has intelligently absorbed Titian's influence.[19]

It is inconceivable that Polidoro encountered the many Titian models by accident, but he was clearly in the workshop at various points; most probably in the 1530s and we have documentation placing him there in the mid-1540s at least.

An important point must now be made. Polidoro was born in 1510 or 1515, with many scholars veering towards the latter date. His numerous Holy Families and Titianesque compositions are dated to the 1530s. Polidoro could not have arrived in Venice and instantly set up a workshop of his own. He certainly had one a little later but I propose that these Holy Family groups c. 1530–35, painted when Polidoro was between the ages of fifteen and twenty-five (depending on which birth date is accurate), must surely have originated in Biri Grande, Titian's bottega. That being the case, Titian and Francesco, his second-in-command, would have noted Polidoro's potential. He would have been seen as a competent painter who proved that he could assimilate Titian's style (as did Dente) and he would have been an obvious choice to assist in a large workshop commission such as the Ledbury *Last Supper* in future years, when called upon.

A further factor to consider is the restriction on movement into Venice due to the plague. Mancini states that this was in 1526, so it seems more likely to me that Polidoro was born in 1510 and arrived in 1525. This may seem very young but it was not uncommon in large studios. Veronese employed young boys for simple studio work and they often appear in the large paintings such as the *Feast in the House of Levi* (1573). It was probably a whim and amusement on the part of Veronese but many such boys do appear in his and Titian's work, often to lighten the mood in a sombre subject.

As I have said, we cannot analyse all the paintings by Polidoro, Francesco and Titian where we see obvious links, but a comparison of Polidoro's *Madonna and Child with St Cecilia* in Zagreb (Strossmayerova Galerija, date not available), the *Mystic Marriage of St Catherine* (*c.* 1520–40) in Hampton Court, linked with Francesco and Titian's *Madonna of the Cherries* (*c.* 1515) in Vienna, all have common points. There is sufficient evidence to place Polidoro da Lanciano in Titian's shop before 1526 and therefore in a position to develop his own style, as well as to assimilate with others in the studio to collaborate successfully.

In 1525 Titian was living in the San Polo sestiere (district) and we have documentation showing that Dente was there as well. Titian then moved to Fondamenta Nuove on the northern shore of Venice and the house/workshop of Biri Grande in 1531, where he remained.

FRANCESCO VECELLIO

Returning to Francesco now, as we saw he was Titian's first recognisable assistant. We cannot examine all his early work here but we may note his S. Vito di Cadore Altarpiece (1520–25) which recalls Titian prototypes and 'Polidoro types', as do other works. Much of Francesco's own early work was outside Venice, but he paved the way for the younger generation of the family and, importantly, established connections with other workshops, especially that of Polidoro.

Francesco has many paintings attributable to himself as well as being Titian's primary collaborator until his death in 1560. There is no doubt that whilst he intervened in many Titian paintings, his collaboration was so highly successful that his input is difficult to determine.

As I mentioned earlier regarding Girolamo Dente and others, no thorough technical examination has yet been made on the collaborators, with the result that opinions are subjective rather than based on underdrawings, media analysis and pigment analysis. That which is constant throughout most of Titian's works is a constancy of references, models and ideas, reflecting the centre of the 'solar system', Tiziano Vecellio. We have to keep in mind, however, that despite the many names which we

encounter, these were most probably occasional collaborators, some staying longer than others certainly, but it was perhaps a family group who accompanied Titian to Augsburg as painters: Orazio and Cesare. It was Orazio who took over the studio in 1560 after Francesco's death. Also, at that point Emanuel Amberger is documented as an important collaborator from the mid 1560s.

Dente died in 1572, leaving Amberger, Marco Vecellio and Valerio Zuccato as the main collaborators.

COLLABORATORS, FOLLOWERS, APPRENTICES AND OCCASIONAL HELPERS

We saw that Vasari, Ridolfi and Boschini all list many disciples, followers and apprentices. The respective places of these many artists is addressed in *Le Botteghe di Tiziano* and we have no need to examine the associations and interpretation of terminology here. We do, however, need to appreciate that whilst some were excellent and 'successful collaborators' – that is, their work blended so well with Titian's as to be indistinguishable – other more competent painters would be inclined to follow their own paths. The sixteenth- and seventeenth-century writers who considered this problem tended to place a different emphasis on the importance of the many names involved and, indeed, placed Titian's role in the workshops differently. This subject is very complex and not altogether relevant to our study. In addition, paintings attributed to one artist will be re-attributed years later, and in the future, as technical examinations are made, the process will be repeated.

Moreover, private Venetian collectors recognised Titian's fame and wanted a recognisable Titian work, so the success of these replicas continued as the disciples produced increasing numbers of them.

What then is the relevance of this long digression on the Vecellian workshop? Clearly, all Titian's followers were not merely producing versions; some remained in the shadow of the workshop whilst others developed a unique style. Even then, Titian's techniques were not constant and formulaic, so recognition of a disciple/collaborator/pupil is extremely challenging.

As we have seen, it is interesting that even whilst collaborators moved on, they would often still sign their own work with Titian's name as well, so important was the cachet of having worked with the master. Some did so when even briefly in the workshop, such as Camillo Ballini, while Dente signed as Girolamo Tiziano, and Simone Peterzano as TITIANI ALVMNVS in his *Pietà* (1584, San Fedele, Milan) and even in his 1589 self-portrait, long after leaving the Titian bottega.

As the 1560s and 1570s progressed, relationships become more clarified and we have names such as Palma il Giovane, who was certainly in the shop in 1576/7 and Dominikos Theotokopoulos – El Greco – with his *Purification of the Temple*, with obvious portraits of various artists in the foreground, including, significantly, one of the old Titian.

FIG. 4.15
El Greco
The Purification of the Temple (detail)
1571–6
oil on canvas
117 x 150 cm
Minneapolis
Institute of Art

It is evident that the various observations of Vasari, Ridolfi and Boschini are sufficiently in non-agreement to confuse us further, in part at least. This basically means that whilst our *Last Supper* was created in Titian's workshop and we know those present and we can even, to a point, identify some of their styles, are we looking at heads and figures by an artist attempting to integrate, one of Titian's collaborators, making identification almost impossible, or is there another possibility? I suggest that *The Last Supper* was created over a much longer period than was usual, partly during

FIG. 4.16
Damiano Mazza
Rape of Ganymede
1575
oil on canvas
177.2 x 188.7 cm
National Gallery,
London

some of Titian's travels to Rome or Augsburg and by a range of artists who happened to be in the studio at the time. This would account for the disparity of styles and inconsistencies, as well as the archaic composition in a work partially completed – see, for example, the tiny date of 1576 above the two portraits near the pentimento head. It is almost certain that the changes in that area were made some time after *The Last Supper* was thought to be finished, or at least near completion, but as we know work continued until around 1580.

This we shall look at closely later. The timespan may seem unreasonable but, as we noted earlier, the *Vendramin Family*, for example, took sixteen years to complete and was commissioned by a wealthy and important client.

Many painters were passing through the shop during the painting's stay, from the young Palma il Giovane to the young Damiano Mazza who died on 25 August 1576 – two days before Titian – aged twenty-six but who was capable of imitating Titian's technique to a remarkable level, as can be seen in the National Gallery's *Rape of Ganymede* (*c.* 1575). In 1878, Cavalcaselle

considered that *Ganymede* may have been from a design by Titian.[20]

Fossaluzza has identified a group of works attributable to Mazza, as had previously von Hadeln in 1913 and Cavalcaselle in 1865.[21] We find comparisons with Titian, phrases such as 'the stupendous busts of the evangelists' at the Vienna Academy and 'Mazza went so close to Titian's late work'. Fossaluzza concludes, 'we can hardly find another capable of coming so close to his style'.

We know that despite Mazza dying very young, he was an important collaborator in Titian's late years, which means he must have been in the shop when the Ledbury *Last Supper* was being created, but we have no documentation linking him to it.

It has to be remembered that there were many important commissions in the process of completion at any given time and that all the best available collaborators would be spread throughout Biri Grande. They would not all have necessarily been involved in our *Last Supper*.

1. E. Tietze-Conrat, 'Titian's Workshop in his late years', *The Art Bulletin*, Vol. 28, no. 2, 1946, pp. 80-81.

2. G. Tagliaferro, B. Aikema, M. Mancini and A.J. Martin, *Le Botteghe di Tiziano* (on Calcar), Florence: Alinari, 2009, pp. 343-5; Robert Proper, 'Jan Stephan van Calcar, a little known self-portrait', *Bulletin of the History of Medicine*, John Hopkins University Press, Vol. 3, 1959, pp. 466-9.

3. Alessandro Ballarin, 'Profilo di Lamberto d'Amsterdam', *Arte Veneta*, XVI, 1962, pp. 61-81; Alessandro Ballarin, 'Lamberto d'Amsterdam, le fonte e la critica', Instituto Veneto di Scienze, *Lettere ed Arti*, Stampiera di Venezia, In-8, 1963, pp. 335-66; N. Dacos, 'Lambert Sustris and Jan van Scorel', *Arte Veneta*, 2000, no. 56; Bert Meijer, *Over Jan van Scorel in Venetie en het vroege werk Van Lambert Sustris*, 1992, vol. 106, Netherlands, Oud Holland.

4. Tagliaferro et al., op. cit., pp. 347-9; Bert Meijer, 'New light on Christoph Schwarz in Venice and the Veneto', *Artibus et Historiae*, 1999, vol. 20, no. 39, pp. 127-56.

5. Veronesian influences, see references to Sustris and Schwarz collaboration together with Veronese at the Villa Giunti, Magnadola. Parrasio would certainly have discussed the Maser paintings with Schwarz and Sustris, and possibly with Dente too. Did the boys emerging through doorways originate at Maser or are they based on Dente's *Annunciation*, completed several years earlier? We can only speculate on this problem.

6. Parrasio Micheli, *The Sacrifice of Melchizedek*, Cappella Montefeltro of San Francesco della Vigna, Venice.

7. M. Gregori, 'Sul venetismo di Simone Peterzano', *Arte Documento*, 1992, p. 6; Dal Pozzolo, *Il Primo Peterzano*, Venice, Venezia Cinquecento, 2012.

8. A. Donati and L. Puppi, '*The Four Seasons* by Girolamo Dente and his role in and outside Titian's workshop', conference on Venice and Puglia in the sixteenth century, 2013.

9. López de Aragón/A. Donati, '*The Four Seasons* by Girolamo di Tiziano', *Arte Antiguo*, Madrid (online); Tagliaferro et al., op. cit., pp. 154-7.

10. Jan Żarnowski, 'L'Atelier de Titien, Girolamo di Tiziano', *Dawna Sztuka*, 1, 1938 pp. 107-29.

11. Tagliaferro et al., op. cit., p. 103; Żarnowski, op. cit., pp. 107-29.

12. Tagliaferro et al., op. cit., pp. 102-06.

13. Roy Fisher, 'Titian's Assistants during the Later Years' (PhD thesis, Harvard University, 1958), 1977: 'his [Dente's] identifiable appearance in these years is symptomatic of a change in Titian's workshop, for in the earlier years the assistants were completely submerged beneath the Titianesque idea that their own personalities were never allowed to register on the final product', p. 42.

14. S. Claut, 'All'ombra di Tiziano, Contributo per Girolamo Dente', *Antichita Viva*, 1986, XXV. no. 5-6, 1986.

15. Vincenzo Mancini, *Polidoro da Lanciano*, Lanciano: Casa Editrice Rocco Carabba, 2001.

16. Alessandro Ballarin, *Gesamtverzeichnis der Gemalde*, Berlin, 1996, p. 98; Vincenzo Mancini, *Polidoro da Lanciano*, Casa Edrice, Rocco Carabba , 1991, p. 135.

17. Mancini, op. cit., pp. 92-4.

18. Ibid. p. 91.

19. Tagliaferro et al., op. cit., pp. 111-19.

20. G.B. Cavalcaselle and J.A. Crowe, *Titian: His Life and Times*, London: John Murray, 1877; Tagliaferro et al., op. cit., p. 182.

21. Fossaluzza, *Among the disciples of Tiziano, Damiano Mazza and the Ceiling of the Sartori School*, Verona: Studi Tizianeschi, 2011, Vl-Vll, pp. 97-116.

5

TECHNICAL EXAMINATION
AND THE RELATIONSHIP
WITH TITIAN'S WORKSHOP

There are six later works by Titian in the National Gallery, London which have been exhaustively examined by Jill Dunkerton, Ashok Roy, et al. Underdrawings have been revealed by digital infrared reflectography, medium analysis by gas chromatography-mass spectrometry and dyestuffs (a development in sixteenth-century Venice) in red lake pigments by high-performance liquid chromatography. Materials and cross-sections were examined by optical microscopy in visible and ultraviolet light together with a scanning electron microscope, energy dispersive X-ray analysis and other infra-red micro spectroscopic imaging.[1]

I have studied all these results and examined the Ledbury *Last Supper* under 20x binocular microscopy and ultraviolet light, trying to compare and find similarities of technique, pigments, combinations of media, brushwork, paint layering and glazes that give any relevant information.

We are looking at Titian's studio practice in his later years whilst not considering that the master worked on the top layer of the painting.

CONDITION REPORT

The present condition of the picture does not reflect its original character. First, there are almost no glazed colours. This was an essential part of Titian's technique in a complex build-up of paint layers. He would certainly have passed this on to his workshop. In places there are very thin remnants of glazes and, similarly,

in shadows there are hints of lost pigments. The painting was cleaned around two centuries ago and some restoration made. The quality of this was very poor and it seems likely that many subtle glazes were lost. This is indicated by the thin paint in many places where a solvent of excessive strength was used. (A glaze is pigment mixed with – probably – the same varnish later used to varnish the picture surface. This may result in a careless restorer removing the varnish, copal or mastic, and also removing the glazes at the same time.)

Secondly, most of the blue pigment is smalt, which, as we shall see shortly, degrades and turns brown, changing colour balance in the painting and causing purples mixed with smalt to similarly change to a more reddish-purple. This change is significant in our painting.

FIG. 5.1
Smalt, two images:
boy on the left of
The Last Supper and
boy on the right

There was a heavy layer of yellowed copal varnish and considerable damage to the lower left corner where poor restoration was heavy. There were many smaller areas of retouching and countless small paint losses. In this context, it is curious that Skippe reported the painting to be in good condition in 1775 and yet I would estimate the restoration to be around 1800. This suggests it was damaged badly en route or after it arrived in England.

THE CANVAS

The two parts of canvas had started to separate and lift, causing paint loss along the join where the thread had degraded. Venetian looms were around 40 in (102 cm) and our larger section is 44 in (112 cm) This is unusually large, given the reduction in size. To solve this problem the canvas was lined on to a new linen canvas with vegetable or animal glue c. 1800. It seems likely that the ironed hot glue-starch did not penetrate sufficiently to hold down the canvas and heavy paint layer, or it was stored in a damp environment for some years which degraded the glue. The latter is the more likely.

The canvas is plain or 'tabby' weave with 13 threads per centimetre. Titian tended, generally, to use a finer canvas with 25 threads per centimetre when he was in Augsburg, but in Venice he used a coarser weave, as did the workshop. These had more irregularities and raised threads requiring a gesso coating. This is very obvious on our painting.

A visitor to Ledbury noted that 'a vicar' had folded the painting and put it in his attic. It was later sent to a London auction house for a valuation in the early twentieth century, where it was valued at £25,000. I have no further documentation on this but such treatment is not ideal for an old canvas. The auction house involved had no record when asked.

The damage to the lower left of the canvas tells us that it sat on the floor in a hazardous position for a considerable time. This is most unfortunate, since it is precisely where remnants of the signature are found.

The stretcher has only one cross-bar, and I suspect it was made by a local carpenter, since it has no expandable corner

mitres to tension the canvas. This would have resulted in a slackening of the canvas in damp conditions and probable subsequent lifting of paint.

GESSO AND GROUNDS

The next stage was preparation by the application of gesso. Titian's gesso preparation was inconsistent, so we may expect the workshop helpers to have produced much the same. The gypsum varies between slaked (gesso sottile) and raw. The relevance of gesso in our *Last Supper* is that it is used to fill depressions primarily, and it varies in thickness. Little is applied on top of the threads, so in most areas we are aware of the canvas texture.

Craquelure is varied throughout the picture surface, and other than being caused by the passage of time two other factors often contribute. The first is a different thickness of gesso which causes cracks under damage or stress, and the other is caused by an artist working over paint which is not sufficiently dry. The former is evident in the serving boy on the right and the smooth surface suggests that area was carefully prepared for a more subtle technique of painting. There is also a slightly lighter grey/green imprimitura which now shows clearly where the top layer of paint has worn.

Titian occasionally used a grey or beige imprimitura in early work but later work is on a white ground. Coloured and dark primings were being used in other centres but Titian's use of them is rare. Tintoretto, however, used them in the late 1550s. Our painting has a dark ground in many separate areas, as may be seen through the craquelure and thinner paint surfaces. The tablecloth ground is particularly apparent and a dark ground beneath the white seems a curious choice. Generally, grounds were painted all over the gesso with a large brush and this evidence of varied grounds must surely indicate each was the choice of the artists involved, probably from different studios or centres.

Since the pentimenti eyes of the boy on the right appear to have no overpaint, we are left to wonder why. The need to be precise in the gesso finish and the wider range of pigments found (including some lac lake colour, absent in many of the other heads) suggests a portrait.

Another cause of craquelure, painting on an only partially dry base coat, may be seen in many places but, significantly, not in the two portraits on the left. These are master painters, taking great care with ground preparation and paint layers in their portraits.

THE DRAWING

The next stage in the creation of our painting was the drawing. It would certainly have been prepared in the High Renaissance manner typified in Leonardo's *Last Supper*; many sketches from life, sketches of groups, a complete drawing and a full-size cartoon from which a spolvero was created with pricked holes pounced through with charcoal to create outlines and which could be made separately. Having examined our painting in fine detail, there is no evidence of pouncing. There are also no existing cartoons from this workshop or from any others. There are almost no drawings from Titian which relate to a painting, although many must have existed.

Another possibility is a transfer. This is a mechanical process completed by assistants and would be accurately followed when painting. However, I can find no evidence of any transfer, which does not mean it did not exist, but one would expect some trace. We also have very many changes and pentimenti. This all suggests that rather than the transfer that was used in Titian's many replicas and variants, we may well have a composition drawn freehand, possibly first in chalk.

An X-radiograph would help clarify this and show different styles of underdrawing, perhaps. Alternatively, it might show one hand drawing the entire composition, possibly with a basic transfer.

In fact, there are many freehand drawn lines throughout the painting, applied with a brush. Some are light brown and others are black. They can be seen especially on the portraits on the left between the figures. In this area there are examples of very thin remnants of glazes and thin paint surfaces, allowing us to see some free black outlines. These outlines are corrected, creating two lines and, highly significantly, on the figure of Andrea Vendramin (in the National Gallery, London) we have just such a form of black line showing clearly through his red robe.

(Opposite)
FIG. 5.2
First and second apostle from the left

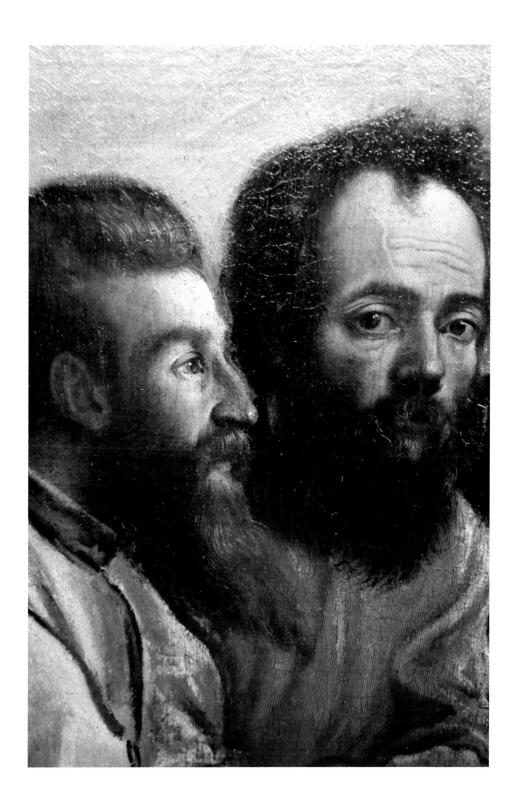

FIG. 5.3
Vendramin family
(detail)
1543
oil on canvas
206.1 x 228.5 cm

The underdrawing in the *Vendramin Family* is characteristic of Titian; free and bold and showing Titian developing much of the poses whilst painting. This may be seen in his early work but it is much in evidence in later work. The *Vendramin Family* is dated *c.* 1540-45, with later reworking *c.* 1555. Much of the figure painting follows the underdrawing and Titian's revisions included the boys to each side, indicating a continuous creative process. This same characteristic is found in many works of Titian, even if only his paint flows over an underdrawing to make small changes in poses.

The significance of this is, of course, that just such a process is found in the Ledbury *Last Supper*. Obviously, this fact alone cannot be the basis of an attribution but it must strengthen the case for Titian having completed at least some underdrawing and continuing to oversee the composition and advise changes.

We have, then, no evidence of mechanical transfer but we do have evidence of freehand underdrawing together with many changes as part of the creative process. The anomaly here is that freehand drawing suggests a master painter, yet we cannot see Titian's hand, whilst a spolvero or transfer suggests a workshop. There are, however, Titian works with careful underdrawing, doubtless made by cartoon transfer by assistants (for example, the Prado *Venus and Adonis* of 1554). We cannot generalise but in the case of our painting my own feeling is that Titian was involved in a freehand chalk drawing and then the underdrawing with a fluid black painted line – with Francesco, if before 1560.

We also have to consider the many changes, not just the obvious pentimenti boys and additions. A workshop painting would surely have a full transfer and, thus, no pentimenti, yet we have many alterations suggesting the creative process continued.

FIG. 5.4
First and second apostle from the left – underdrawing

In *Venus and Adonis* it is generally accepted that Titian made the changes and additions himself, having instigated a full transfer first. Clearly, then, underdrawings may vary, so we have to ask who was responsible for the initial composition, separate (lost) sketches and production of what freehand drawing is apparent.

I suggest again that if this was before 1560, Francesco was partially involved, together with Titian but if after 1560 then Titian must have worked on it. At this point, neither Orazio nor Dente are likely to have orchestrated such a large-scale work. We also have evidence of the Titian signature; Titian obviously had some involvement in this painting, having signed it – or instigated the signature – and the drawing is the only possibility.

MEDIA AND PIGMENTS

We next have to consider pigments and paint medium. By the second half of the sixteenth century Venice was a noted centre, with the Vendecolori supplying pigments throughout Europe.

The finest quality and the most expensive grades of lapis lazuli – ultramarine – could now be obtained from the suppliers in Venice. Its source was the present Afghanistan and it was only used for important work, such as Titian's royal clients.

Another source of blue was azurite, or 'German Blue', as it was brought in by Germans across the Alps. Azurite could have a richness of its own, especially when of high quality and it was often used as a base for lapis, thereby reducing the quantity required.

SMALT

The identification of specific pigments tells us little, since all painters had the same availability. The bottega certainly increased its palette and in our case one addition was the blue cobalt glass pigment, smalt. Good quality smalt resembled ultramarine – the very costly lapis lazuli. However, it was not appreciated that smalt would invariably degrade, especially if not mixed with lead white. The process then resulted in a dull grey-brown. The ground glass was initially a by-product of the Venetian glass industry, although when made into a pigment it was finely ground and often richer in colour.

It was then mixed with linseed oil or walnut oil, although the latter tended to produce early wide cracking. This is seen on the serving boy on the right; however, his tunic shows touches of blue in places and it appears that the smalt was overpainted in azurite, although minimally, since the overall colour is a dull blue-purple.

The serving boy to the left has a similar quality and his sleeves are of smalt, which has degraded to purple-brown. The back of his gown is a dull purple-black with wide cracks, indicating smalt mixed with indigo, black and walnut oil. Its front has a smalt base but the top coat of paint appears to be azurite. It was common in important paintings for smalt to be used as a base colour, which was then overpainted in ultramarine, and Titian frequently adopted this technique.

Since smalt has been used extensively in our painting, we must consider what the original appearance would have been.

The two boys would have had rich dark blue tunics, as would the fourth apostle from the right, although the highlights, mixed with lead white, have retained some colour. The fifth apostle from the left has a gown of lac lake mixed with smalt, so the strong blue-purple has faded. The second figure on the left, in red, has thin remnants of purple in the shadows. The form is quite weak and there were obviously more shadows to create form, but now we are left with white highlights and a high-quality red earth pigment. The shadows are merely pale glazes, suggesting the darker colours were lost in an old restoration.

It is obvious, then, that smalt has essentially altered the appearance of the Ledbury *Last Supper* into a far less vibrant composition. Quantitative analysis would establish the grade of smalt. Low-grade smalt would have less potassium and consequently degrade more, although this also depends on the degree of grinding. Larger grains tend to retain more colour. Veronese's paintings sometimes have a similar problem.

RED LAKE

Another change which we find in the workings of Titian and his bottega is the use of red lake pigment based on cochineal. This was now available from Mexico, imported from America and used in the dying industry in the 1540s and 1550s. Prior to this, Titian used

Kermes, from the scale insect Kermes Vermilio Planchon. This is still found a little after 1540 – for example, in the *Vendramin Family*. Identification of both is difficult. The Kermes-based pigment was expensive and therefore the cochineal red lake was generally found in the workshops of Titian, Tintoretto and Veronese.

Titian himself built up red/pink draperies with near white highlights on the red lake glazes. Our fourth apostle from the left is formed in much the same way and although there is little remaining of any top glazes, the basic colour has the rich semi-translucent lake colour which we find in many Titians (for example, *Diana and Callisto* of 1556–9 in the National Gallery, London). The Titian also contains red lead whilst our apostle is restricted to varying tones of red lake and lead white. The same red lakes are used throughout our painting, often mixed with smalt, with the resulting dull purple.

CINNABAR

Vermilion, made from the mineral cinnabar, is very limited in our painting, even in flesh tones. For preference, I believe we see high-grade red earth, since no grains were visible under high magnification. This can still have an intense colour, and our portrait on the left is probably red earth, some lake pigment and a very small quantity of vermilion. A scanning electron microscope would clarify via cross-sections.

YELLOWS

The orange draperies in the third figure from the right are formed from a ground of red/yellow earth, forming an orange/ochre with orpiment overpaint and a thin line of lead tin yellow to the right. Veronese and Tintoretto tended to use realgar (ruby sulphur) and orpiment, both arsenic sulphide mineral pigments, but these were used much less by Titian. As with most pigments in our painting, we find typical Titian and Titian-workshop combinations of pigments.

GREENS

Greens in the workshop were sometimes yellow earth with verdigris, but more often lead tin yellow with verdigris. There were several of these giallolino pigments available and we have documentation of Orazio buying Giallolino de Murano, which was clearly related to the glass industry. Green is very limited in our picture but appears in the boy on the right, who has malachite in walnut oil in his tunic. The apostle to the far right has a dark green robe but this is a later addition, probably added during the *c.* 1800 restoration. In two places tiny flakes showed a bright green beneath and whilst the size is too tiny to identify by observation, the ground would appear to be a mixture of lead tin yellow and azurite.

We also find verdigris in the sky pigments with linseed oil and the dark tones comprise azurite, indigo and smalt (degraded). A few limited areas were mixed with lead white which has protected the blue, and the richer dark blues have been lost.

1. J. Dunkerton and Marika Spring, 'Titian's painting technique to 1540', London National Gallery technical bulletin, 2014, vol. 34, Yale University Press; J. Dunkerton and Marika Spring, 'Titian's technique and style in his later works', London National Gallery technical bulletin, 2015, vol. 36, Yale University Press; N. Brommelle and P. Smith, *IIC Conservation and Restoration of Pictorial Art*, London: Butterworth and Co., 1976; Barbara C. Anderson, 'Evidence of Cochineal's use in Painting', *The Journal of Interdisciplinary History*, 2014, XLV:3, pp. 337-66; Rosamond D. Harley, 'Artists' Brushes: Historic evidence from the sixteenth century to the nineteenth century', *Conservation of Paintings and the Graphic Arts*, 1972, pp. 123-9; John S. Mills, *The Identification of Paint Media*, London: National Gallery, 2014.

6

SIGNATURES
AND DATES

THE INCIDENCE OF SIGNATURES
IN VENETIAN PAINTING

The generation of painters that included Lorenzo Lotto and Titian tended to sign their paintings, whilst the next generation, including Veronese and Tintoretto, did so less often. In the Renaissance we often find the cartellino (a small curled parchment) bearing the signature. This came to be associated with a 'workshop' or 'artisan' and the younger men frowned on such obvious devices, with signing in Venice becoming less prevalent.

Titian did, in fact, sign his work increasingly as the century progressed, and in his last twenty-five years, as many of his paintings were destined to be sent abroad, he made a point of clear signatures. He was an astute businessman with a wealthy lifestyle and understood the value of his name being recognised.

Signatures were by no means limited nor limited to specific times and, in fact, Giorgione appears not to have signed at any time, but there was a general disinclination with the artists born early in the century. By around 1540, the practice started to develop again as, no doubt, the new painters appreciated that they needed to have that business acumen and a need to be recognised, as they had seen in Titian. This made their names known, particularly if they were also selling abroad, where their names were not as familiar.

The Early Renaissance, the quattrocento, saw a move away from the co-operative guild system to an emphasis on the

individual, and it soon became clear to the young painters that the perceived individuality of the creator was essential to sell work. As the new painters were now having to redefine the move away from signing, we also see more ingenious methods used as they observed Titian and other major painters hiding signatures on clothing, shoes, architecture and, in our case, on a water ewer. Documents do exist (investigated by Charles Hope) that suggest, in some cases, that Titian signed to differentiate his work from a workshop piece or an assistant, even one with the considerable ability of Dente.

What is of great importance for the Ledbury *Last Supper* is the fact that we not only find a contemporary Titian signature, matching some others in his own hand, but we have in addition a finely drawn monogram of Girolamo Dente with a date, together with a

FIG. 6.1
Girolamo Dente,
signature

further date of 1576, enabling us to know when the two portraits on the left were made. Not only is this addition of another name exceptional, but we now have to consider possible lost signatures by other assistants. Having examined the paint surface for many months under studio conditions and noted the fact that there are certainly losses of paint fragments, thinned paint and losses of glazes (which could have been overlaid with a name), I believe that it is probable there were other monograms. We know from the varying styles of painting that several more painters were certainly involved in this painting, and it seems highly probably that they would have wanted to add their names as well.

This amount of information is extremely rare for the years 1560–80, so let us examine the discovered names.

Three sections of signatures and dates have now been discovered. Remarkably, none were visible under normal light and only by examining the entire canvas under ultraviolet fluorescence under 10x magnification were they found. Each is also very small and each has some damage or loss.

The first is the monogram. This is on a dark background on the right wall and, curiously, on its side. Girolamo Dente used several signatures which have been identified and there can be little double that this monogram is his, as yet unseen. He used the following:

HIE D TICAN
D TITIAN
HIE. (Roli) mo
HIE.MO D TITIANI
(No 21) [this number may be a later addition]

On our monogram HIE may be interpreted in the centre and MO lower left with the date '6'? Probably '4'. Dente has signed other works HIE MO and '2' date letters. This would place Dente in the workshop at, and probably before, 1564, when *The Last Supper* was in progress. We are not certain when he left but he was reported to have stayed for thirty years.

Another tiny inscription is in the form of a highly significant date above the repainted area of the two portraits: 1576. Old craquelure runs through the '7' and microscopic examination has

FIG. 6.2 determined that the earlier serving boy – the pentimento head
1576 date and another faintly visible to its right – was overpainted before
the new boy and two portraits were added.

The significance of this is as follows:

1. I initially considered the serving boy on the left to have been
painted by Dente, who died in 1572. His monogram is dated 1564,
around the time he is thought to have left the workshop.

2. The boy bears a strong resemblance to the Vendramin boys on
the left in Titian's family portrait in the National Gallery, London,
particularly the boy on the right of the three. The pigments appear
much the same – earth pigments – and the technique of building
the impasto paint in layers, rather than using glazes, is the same.
Nicholas Penny identified the three boys as being by Dente.
However, it is quite clear that the brushwork and technique is
quite dissimilar to that used by Dente in *The Four Seasons* and the
Ledbury *Last Supper*, and Nicholas Penny's assertion does not, I
feel, lend any weight to Dente having painted the boy on the left
in our *Last Supper*, despite what would seem a sound comparison.
In the Ledbury painting it could surely not be the case that
Dente painted our four apostles and then changed his painting
technique and brushwork for that serving boy to the left. I can
offer no explanation for this anomaly but feel one must assume

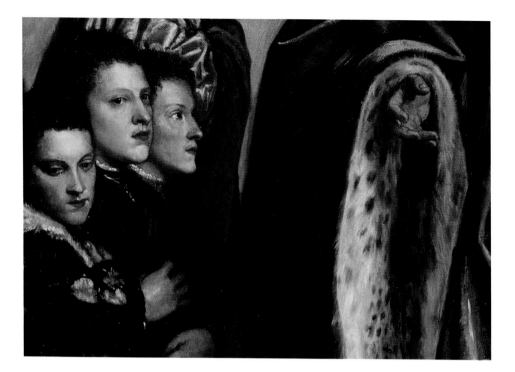

that in the *Vendramin Family* Dente modified his technique and that the similarity to the left serving boy is purely serendipitous. Moreover, scientific examination indicates that the left boy was almost certainly painted after the 1576 major changes in that area and Dente died in 1572.

3. The two portraits were added after the overpainting, as was the boy (see Chapter 5), so the 1576 date must refer to them rather than the changes or the boy. The portraits were, therefore, painted in Titian's and Orazio's last months of life – either before August 1576 when Titian died or after they had both died and therefore October–December 1576.

4. We cannot know when the changes were made behind the two heads and around the boy. The paint on the doorway had certainly dried so it could have been at any time between 1564 and 1572, when Dente died.

5. The importance of this discovery is, of course, that if the heads were completed after 1576 we know who was in the workshop completing unfinished paintings under the supervision of Pomponio and Marco Vecellio. We have no way of knowing which other parts of the painting were also unfinished, if any.

FIG. 6.3
Vendramin family
boys on the left
1543
oil on canvas
206.1 x 288 cm
National Gallery,
London

6. The background architecture was completed before the figures, since they are overlaid and the Dente monogram appears on that architecture.

The overpainting of the first boy is important in our dating; that is to say the obvious pentimento head, there being another overpainted head a little to the right as well. Initially it appeared that the dark pigment from the door on the left to the second apostle was a dark ground, as appears in other parts of the painting. However, it stops there and the ground up to the left corner is a pale earth colour. It seems, therefore, that the dark was, in fact, a painted wall since it cannot be a shadow as is clear from the light source on the right. There seems no explanation for its cessation but there is no doubt that it was overpainted at the same time as the pentimento head. The pale grey-green extends to the boy who was painted after the background change. There will be more details on this in Chapter 7. The boy was not in the original design.

Below the boy's tunic, dark pigment shows clearly through the craquelure, together with orange lines in a triangular form which remain a mystery. The tunic of our left apostle was then painted over the new lighter colour. On close examination of the hair lines and contours in this area, we are able to see that the heads, clothes and hair were all painted after the removal of the pentimento head.

The third signature is found on the ewer on the floor. This area of the painting has been badly damaged and there is much flaking, abrasions, paint loss and tears. Under normal light nothing was visible other than indeterminate black marks in places. Macro-photography under ultraviolet light started to show an indication of letters around 0.6 cm in height and after much time on computer programmes, enhancing the pigment which appeared to be letters and reducing those marks in other surrounding pigments, the shapes began to take form. A careful examination of all Titian's known signatures then showed that not only could we now read TITIANVS but that it is written in a hand which may be recognised as being similar to that written on Titian paintings. The date is probably below but very little remains to be able to read it.

FIG. 6.4
Photograph of
the jug before
using ultraviolet
light

FIG. 6.5
After the
ultraviolet
was used

FIG. 6.6
Titian's signature

TITIANVS·F

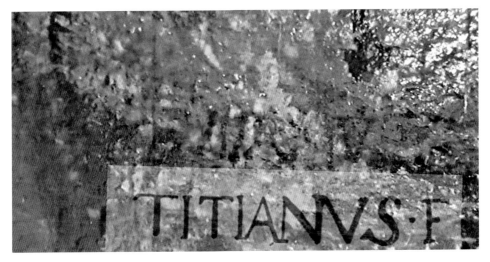

FIG. 6.7
Signature with image using Titian signature Titian's original overlay; another signature to show example of a Titian the close match signature seen of T, I, A, N and V under ultraviolet letters light; an overlay

FIG. 6.8
Titian's signature

TITIANV̄

There are several important points about this obviously major discovery. The first is that since microscopic examination shows this is indeed an original signature, the fact that it came from Titian's workshop indicates that he would surely have wished to sign the painting or have it signed, despite not having worked on the figures.

In the mid-1570s Titian was becoming ill before contracting the bubonic plague, his eyesight was probably poor and he could not have readily signed so small. Therefore, it seems likely that if an assistant did not add the signature on his behalf, he signed his name a little earlier, while *The Last Supper* was very near completion. The style of the letters does relate to earlier signatures but they are very small and lack definition, partially due to damage.

John Skippe did state that he had bought a Titian in 1775, signed and dated. There has been no proof of this assertion other than that early reference. There can be little doubt that this is the lost signature which had become damaged when the painting obviously spent some time on the floor. The damage is almost all in the lower left area.

The overlay of our *Last Supper* signature and that of a Titian is a moving image but in our illustrations we can only, of course, show separate images.

7

THE PENTIMENTI
AND ALTERATIONS

There are many pentimenti in the Ledbury *Last Supper*, some minor and some significantly large. We have to ask why the changes were made, when and by whom, since some have great significance, as we have found in dating.

The major change is, of course, around the serving boy on the left, which we have examined previously in a different context. He originally stood behind the apostle in an ochre gown. (The other serving boy has quite a different face, brushwork and green underpaint.) The doorframe now shows through his figure, the structure by his feet was removed and the background was repainted up to the orthogonal line. There is no way of knowing why these changes were made, but since Dente planned the boy on the left, he surely had in mind his figure emerging through a doorway in his large *Annunciation*. As we saw, he also strongly recalls the *Vendramin Family* boy in appearance, brush technique and pigments. Dente would also have been aware of Veronese's fresco work at the Villa Barbaro (1560/61), where two figures emerge through doorways. We shall consider this boy's face, which is undoubtedly a portrait. It is highly significant that this head was painted very late and was not a part of the original composition.

These two figures were not part of the original plan and were dramatic changes. It may be that they were seen as being more in keeping with the new Mannerist illusionism and spatial interest, although the two doors were part of the original plan.

The serving boy to the right is another new hand. He has had both eyes moved down and the original eyes are still clearly visible.

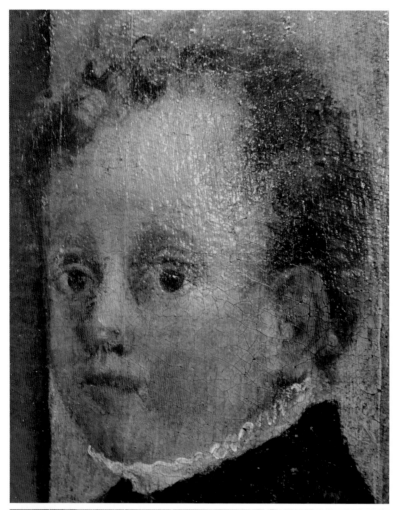

FIG. 7.1
Right serving
boy

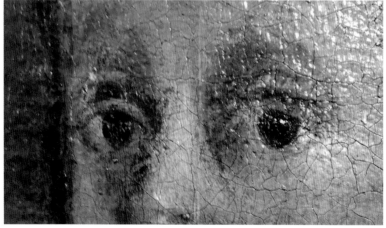

FIG. 7.2
Right serving
boy – detail of
the eyes

His nose has also been moved down (the highlights on both tips are also visible), as has his ear (a faint overpainted ear may be seen). A vital feature of this head is the lack of any underdrawing. The entire head was painted directly on a thin grey-green ground in thin glazes, many of which have been damaged or lost in the old restoration, so that what we see is only a vestige of a beautifully observed portrait head. It is a painting technique which is unlike any other in this picture. The craquelure pattern is different from the Polidoro and Dente faces, being much closer in a random pattern, with none of the long vertical continuous lines we see on many other faces. Clearly there is a thicker gesso, which has contributed to this, but it enabled the painter to work on a smoother surface. We find the same typical technique on the two portraits on the left. The ruffs on both boys were painted by the same assistant, although the garments were painted by two different assistants.

The reasons for the change in the serving boy on the right cannot be known, other than that he was intended as a portrait.

FIG. 7.3
Pentimento head

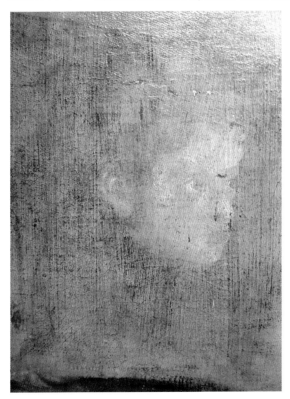

The previous serving boy to the left, the pentimento head, bears no resemblance to either of the new ones, so not only was there a plan to add the two boys later, there was also a decision to change their appearance. The overpainted boy has a more pointed face and chin and an altogether different demeanour.

The second apostle from the right similarly has lowered eyes, his ear has been moved and he probably had other facial changes. The pigments and style indicate that the changes were made by the painter who commenced the heads in each case, although each head was painted by a different painter.

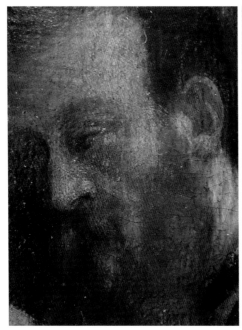

The fourth apostle from the right had similar changes and appears to have had his ear moved down. However, it is now too large and out of proportion. His neck is also too far forwards and it seems that originally the head leaned more forward. His fingers were also lengthened. The third man from the left had his arm moved twice as it rests on the table.

The first apostle on the right is again by a new hand, unidentified as yet; the brushwork is freer and the figure is conceived with stronger tonal values and drama. The pose and lighting suggest a different school, more related to Veronese perhaps. One sees similar types in Benedetto Caliari's work, so I feel that this is someone who, perhaps, worked with Veronese and visited Titian's shop as a helper. As we saw, the model is from the figure to the right in Cesare Vecellio's *Last Supper* and, of course, both Marco and he were present in the shop after Titian's death. The gown has quite a different treatment from the other lake gowns in the painting. It is a mixture of vermilion, red earth and lake with coarsely ground white lead, rather than the thin red lake glazes and lead white highlights used elsewhere in our picture and by Titian. This has created a more intense colour and tone, since there has been no loss of glazes and contrast with the dark green robe.

FIG. 7.6
First apostle on
the right with
hand in the air

However, this apostle was painted after the man to his right, as the latter's pink robe shows through where there are paint losses. The figure has the appearance of being added later, partly due to the darker tonality but this perceived tone is not all original. Other small paint losses show underpaint of an intense light green and if this was retained until later overpainting of *c.* 1800, the colour composition would have probably been less successful. It may be that the original painter changed his mind or used the pale green as his own underpaint with a dark green overpaint. It would require a cross-section examined under an electron microscope to determine this. Regardless, what we now see is primarily a later addition of paint, since it fills the craquelure.

The apostle was also moved several times, as faint underdrawing may be seen on the upper and lower body. I believe he was added after the serving boy on the right, since old paint overlaps the boy's tunic. This indicates that he was painted after

Titian's death, probably by one of the late helpers and certainly not by Polidoro or Dente.

There are many small changes of positions of arms and bodies throughout the painting, which are easily visible in close examination.

Whilst not a workshop change, one must look at the composition of *The Last Supper* and note the fact that it has been reduced in size. It is highly unlikely that the arched windows would have been cut in this way and a look at Renaissance and Mannerist *Last Suppers* shows no precedent. There is no way of knowing how much reduction was made if it was more than the stretcher's width (approximately 10 cm), so even X-radiography would not further our knowledge. It would, however, certainly tell us a great deal about the underpainting and the changes that were made from the original concept.

Given that we know that our painting was commissioned by a suppressed convent (as noted in John Skippe's 1775 letter), the siting would have been known and it is inconceivable that once completed the painting would have been reduced on arrival. Therefore, the explanation would seem to be that even before the convent was suppressed the painting was acquired by the da Mula family, presumably to hang in a palazzo of which they had two: one on the Grand Canal and the other at Murano, much painted, including by Monet. When John Skippe bought *The Last Supper*, one palazzo was occupied by Polissena Contarini da Mula, who was Dogaressa of Venice having married the Doge, Alvise Giovanni Mocenigo (r. 1763–79).

The da Mula family also supported a convent and would have owned some of the items in it. It is probable that the painting belonged to them initially and was then returned to them. This date must have been before 1775, of course. We have no information as to when the da Mulas first acquired the painting and we cannot determine when it was reduced. The family may have received the painting well before Polissena's time and it was reduced then to fit a wall space. This may seem outrageous, but Leonardo's *Last Supper* once had a door inserted into its lower part and one of Titian's *Last Suppers* was drastically cut down.

Another major mystery in our *Last Supper*, and one which could not be resolved, is the question of its actual

FIG. 7.7
Left boy in
doorway

completion. That is to say, are we seeing the picture as it was
originally designed, apart from the changes we have looked at? We
may identify certain painting techniques, colour combinations,
uses of pigments, brushwork, media, and so on, but there is a
strange simplicity to the background. As we saw, there are almost
identical door frames in Dente's *Annunciation* but the lateral
windows (although similar in Leonardo's Santa Maria delle
Grazie) and the arched windows have a notable lack of decoration.
It is possible that such a neutral background helped to accentuate
the drama. This seems likely, since there appears to be no hint of
underdrawing or tracing suggesting potential detail to be added.

The composition will be examined in more detail in the next
chapter, dealing with the sources of the style.

8

THE SOURCES OF
THE LAST SUPPER

Having established that our *Last Supper* was Venetian, mid- to later sixteenth century, the next step was to look at every available *Last Supper* painting created during the late fifteenth century to the sixteenth century in Italy, as well as its source. Since Titian had a basic formal training under Gentile Bellini and then Giovanni Bellini, all potential contacts were considered. These included Taddeo Gaddi from 1340–45, Andrea del Castagno, Domenico Ghirlandaio, Cosimo Rosselli, Pietro Perugino, Leonardo da Vinci, Franciabigio, Andrea del Sarto, Raphael, Albrecht Dürer, Marcantonio Raimondi, Giorgio Vasari and the closer possible sources of Giuseppe della Porta, Paris Bordone, Bonifazio Veronese, Andrea Schiavone, Alvise Vivarini, Cima da Conegliano, Palma Vecchio, Sebastiano del Piombo, Lorenzo Lotto, Veronese and Giorgione, together with drawings.

There were considerable interactions of style and by 1510 Giorgione had died and del Piombo had left for Rome. Bellini was the primary painter in Venice, but after his death in 1516 Titian dominated the art scene in Venice.

The history of the Last Supper image throughout the medieval period, Early Renaissance, High Renaissance and Mannerism is beyond the scope of this study but a look at some of the works, beginning in the trecento, shows that the long rectangular table replaced circular tables and became popular until the sixteenth century. Several different moments are also portrayed.

The apostles remain constant, of course: Peter (Simon), Andrew (Peter's brother), Bartholomew, James Minor, Simon, Philip,

Thaddeus, Thomas, Matthew (the tax collector), James Major (the brother of John), John and Judas Iscariot (Matthew 10:2).

The incidence of the many *Last Suppers* throughout the Renaissance coincides with the development of religious orders and patronage. The many depictions found in *cenacoli* (convent refectories) from the fourth century indicate its importance. The Christian Last Supper follows, in part, the Old Testament Passover Seder, Christ's last meal with His disciples, and all the depictions contain important iconography. The basic Last Supper ingredients are bread, wine and lamb; Christ's body, blood and symbolic sacrifice as the lamb of God.[1] In the Ledbury *Last Supper* we have the usual symbolism together with what appear to be cherries in a bowl (kindness) and some other fruit in front of Christ (fruit generally symbolising generosity),[2] together with the rare depiction of a citron (a large citrus fruit), placed ostentatiously to the foreground of the table.[3]

New research from Tel Aviv University discusses the importance of citron in the religious ritual of the Jewish harvest holiday of Sukkot, the Feast of the Tabernacles.[4]

Citron was a clear status symbol for the Roman ruling elite. It originated in Southeast Asia, and arrived in Rome via Israel. It was very valuable as regards healing properties, had a symbolic use, a pleasant odour and was extremely rare. As only the wealthy

FIG. 8.1
Citron

could afford it, citron had high social status. Does our depiction of a citron relate to the time of Christ or to the sixteenth century? We cannot know this.

A further iconographic possibility relates the Italian name for cedar, which is also the noun 'cedro', meaning citron. There is no positive documentary evidence that Jesus's cross was made of cedar, pine and cypress, but this is the teaching of the Eastern Orthodox church.[5]

In Franciabigio's 1517 Florentine *Last Supper*, we find three windows with shutters and original items of food on the table, including cantaloupe melons and various exotic fruits not usually found. In this case it seems possible that the cantaloupes relate to the Cavalieri of Malta and their travels in the Middle East, given that insignias of the Maltese Cross appear in the painting and the commission was via the Abbess Antonia of the order of the Dames of Malta.[6]

This may seem irrelevant to Ledbury but it is only one example of table items having possible links with a commission. We cannot, therefore, assume that our citron is purely religious symbolism but it could, in fact, indicate the initial commission. We have no documentation on this but it seems very possible that since the da Mula family received the painting back from the convent, mentioned in early letters, they also commissioned it in

FIG. 8.2
Franciabigio
The Last Supper
1517
fresco
180 x 220 cm
San Giovanni
Battista della
Calza, Florence

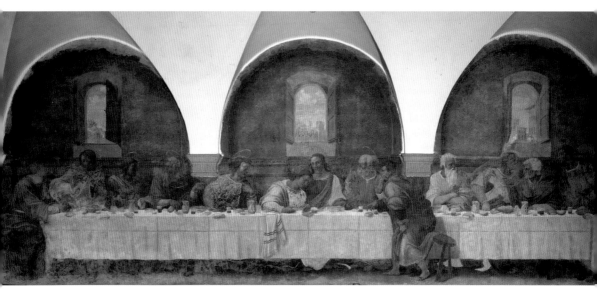

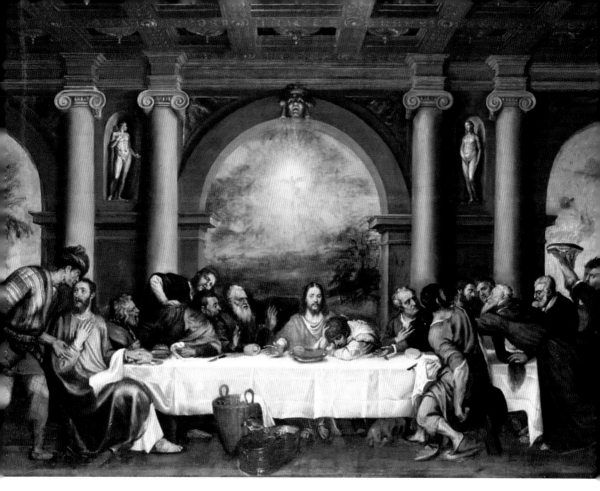

FIG. 8.3
Titian
The Last Supper
1557–64
Pinacoteca di
Brera, Milan

the first place and the citron is telling us something of da Mula and his travels at that time.

Our depicted 'moment' seems to be the breaking of the bread. There is no chalice on the table nor wine in the glasses. Food still rests on platters. The serving boy to the right carries a flask and, curiously, looks directly at us out of the painting. He is also very carefully painted and has the pentimenti eyes, nose and ears where changes were made. In the Titian Brera copy of his Escorial *Last Supper*, the serving boy on the right also looks out at us. This element of a painting is usually reserved for a portrait of the artist involved and we find it throughout the Renaissance.

The format of the long table had a lengthy history prior to and during the quattrocento, of course, but it is from Leonardo, Raphael, Andrea del Sarto and Bonifazio that we learn most of our Ledbury *Last Supper* sources. The gesture by Peter, to the left of Christ, recalls Leonardo's figure to His right and whilst the vanishing point in Leonardo's fresco is on Christ's forehead, ours

is found on His neck. A tiny hole, still visible, filled with a speck of cochineal, is where our painters placed a pin and extended strings to accurately create the one point perspective from the lateral windows and door frames. (Curiously, the floor tiles to the right are accurate while those to the left are not.) The several gestures connecting the Ledbury *Last Supper* to that of Leonardo proves that Titian had seen the fresco or its drawings.

The Leonardo fresco was, of course, in Milan and whilst there was a relief sculpture by Tullio Lombardo in Venice by 1532, I do not believe that there is sufficient detail in it to have created much impact. Several artists would have seen Leonardo's fresco by the mid-century and recorded it, including Orazio Vecellio and Titian himself.

Paolo Caliari's feasts and suppers do not relate closely to our *Last Supper*. The two page boys may well have been influenced by the figures in doorways at the Villa Barbaro in Maser (1560/61), although they may also be Dente's invention from his *Annunciation*, and our boy on the right is very like the boy on the left in Veronese's *Feast in the House of Levi* of 1573. In fact, we find similar boys with curly red hair throughout Titian's and

FIG. 8.4
Leonardo da Vinci
The Last Supper
1494-7
oil and tempera on gesso, pitch and mastic
460 x 880 cm
Convent of Santa Maria delle Grazie, Milan

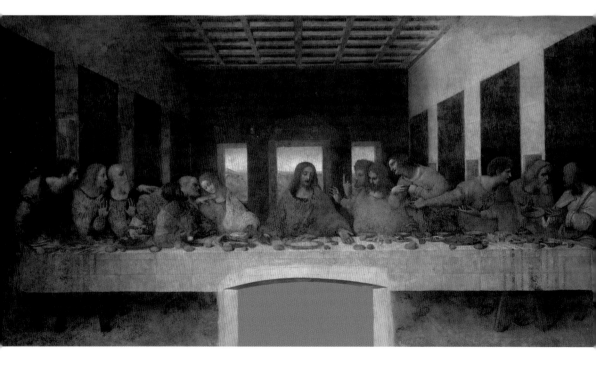

FIG. 8.5
Bonifazio
Veronese
The Last Supper
1530–50
oil on canvas
144.5 x 278.5 cm
National Galleries
of Scotland

Veronese's work. A very similar boy also appears in Polidoro's *Christ and the Adulteress* in Brescia.

The architecture in our painting recalls Leonardo's *Last Supper* rather than those of Veronese, whose architectural backgrounds were complex Palladian, painted by his brother, Benedetto.

Bonifazio Veronese's *Last Supper* in the National Galleries of Scotland was painted in 1530–50, probably nearer the earlier date, and so precedes our *Last Supper*. His early *Last Supper* (date unknown) has many similarities to our painting as well. All three paintings share three openings, and Bonifazio's two, simple, unfluted Tuscan columns flanked by square Tuscan columns and bases on either side appear in both his paintings. Our *Last Supper* shares the three openings and square columns but lacks mouldings on the bases and capitals. The primary feature in all three paintings is, of course, the three openings, also found in Leonardo's *Last Supper*, although squared off at the top rather than arched. (Titian used four Ionic columns, arches, a coffered ceiling and two niche sculptures in his Escorial *Last Supper*.)

Bonifazio's early picture has a limited area of sky and an almost flat wall behind the figures. There is no obvious perspective but we cannot see the top of the parapet, so the vanishing point must be low, probably on Christ's head. In his later work, Bonifazio raises the vanishing point into the sky so that we are now able to view a landscape and experience more depth, whilst the table items are lifted to be seen more clearly as well. By placing

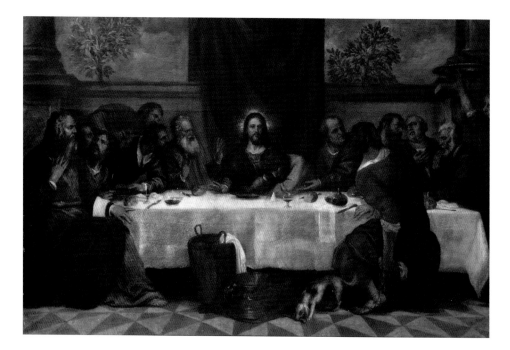

a foreground figure in his composition, Bonifazio has created a circular movement and his figures are now showing more influence of Raphael and central Italian art after 1530, with heavier classical forms closer to the picture plane. There is more tonal contrast and whilst there is still a strong influence of Titian and Giorgione, we now see the type of image which was to influence Tintoretto.

When we compare these compositions to our *Last Supper*, it is immediately apparent that there is more relationship to Leonardo's design as regards the architecture and reduced detail. However, given the three openings each has in common, we have to ask whether, perhaps, this was partially based on the Bonifazio Veronese design because we have some of the same collaborators in Titian's shop as were students with Bonifazio; namely, Polidoro, Sustris and Tintoretto. Having said that, each were young painters and it seems unlikely that they would be consulted on the matter.

A further point is the similarity between the early Bonifazio *Last Supper* and the Titian workshop *Last Supper* in Madrid (not included in Wethey as autograph but accepted elsewhere) with a red draped curtain much like Bonifazio's green draped curtain.

FIG. 8.6
Titian and workshop
The Last Supper
1550–55
oil on canvas
167 x 225 cm
courtesy of Dukes of Alba Collection, Liria Palace, Madrid

The Titian was painted several years – perhaps a decade – after the Bonifazio and whilst the latter has two window openings rather than three, we have the same Tuscan columns, low vanishing point and small area of sky, although with added trees in Titian.

Andrea del Sarto's *Last Supper* of 1525–7 also concentrates on the offering of the bread and lacks wine and a chalice. It has a pink sky, suggesting sunset, as our painting has the dark clouds of an evening sky. The three windows used by Leonardo and del Sarto appear again in our *Last Supper*.

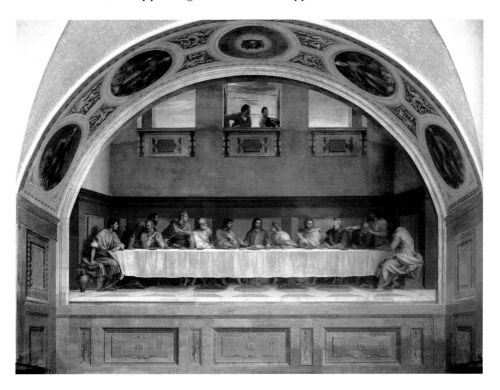

FIG. 8.7
Andrea del Sarto
The Last Supper
1525–7, fresco
525 x 871 cm
Cenacolo di San
Salvi, Florence

It should be said at this point that a vast amount of writing exists on Leonardo's numerical symbolism in his *Last Supper*. Merely noting his use of four groups of three, three windows and Christ's form as an isosceles triangle is a huge simplification of a very complex important Renaissance painting, but full appreciation of this remarkable work is beyond our present scope. There are many examinations into the layers of meaning Leonardo portrayed but we are only looking at the more obvious aspects of it which influenced our Ledbury painting. It is possible that

Leonardo applied Dante's Pythagorean symbolism and numerical method employed in the *poema sacro* (the *Divine Comedy*).[7]

In the Leonardo *Last Supper*, the clasped hands – symbolising Concordia (harmony with one heart) – are reserved for John, who is not fainting as he is in many compositions, including our own. John's peaceful action is a symbol of *fides simulacrum* (an image of faith).[8] In the Ledbury painting we find our fourth apostle from the left adopting this message of faith. We do not know the names of our apostles since, unlike several Renaissance *Last Suppers*, we do not have names written above them. Judas has no upset salt nor money bag, and nor is he being handed bread by Christ, so we can only speculate on the problem.

Raphael had completed two Last Supper compositions in Rome in 1510 and 1515/16. The latter work, made popular through Marcantonio Raimondi's engraving, derives from the Leonardo, whilst the earlier derives from a Dürer woodcut of 1510.

Both were influential for Andrea del Sarto, with the rectangular table, a Renaissance setting, similar disposition of figures and placement of Judas next to Christ. Our own *Last Supper* continues the Leonardo three-window symbolism seen now in Raphael, del Sarto and Bonifazio, and its source must include the Raimondi/Raphael engraving of 1515/16 (a similar ink drawing exists at Windsor Castle, although in very poor condition). We also have our two lateral apostles and our Christ figure is deliberately enlarged, as seen in the two Bonifazios and the Leonardo, although not the Raphael. Some of our sources are, of course, Florentine rather than Venetian but it is not likely that the Venetians lacked access to Florentine developments, proved by the Raphael influence on Bonifazio and just as Leonardo's *Last Supper* was known in Venice.

The original proportion of figures to architecture in the Ledbury painting, prior to its mutilation, with Christ's head placed similarly just below the parapet – would have also been much like that of the Raphael. As previously noted, our vanishing point is on Christ's neck of course, as Leonardo had his on Christ's forehead, but Raphael opted for a higher vanishing point in the landscape.

One important source of our *Last Supper* must, of course, be the Titian workshop *Last Supper*, now in the Escorial, painted in 1557–64. Monks reduced it in size in a barbaric action which changed the composition drastically, losing the serving boy on the right,

(Opposite, top)
FIG. 8.8
Marcantonio Raimondi
The Last Supper
1515–16
engraving
29.7 x 43.3 cm
Victoria and Albert Museum, London

(Opposite, bottom)
FIG. 8.9
Albrecht Dürer
The Last Supper
1523
woodcut
14.6 x 21.3 cm
The Metropolitan Museum of Art, New York

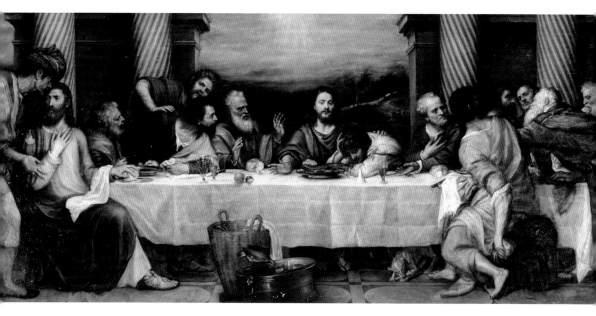

a coffered ceiling, the central arch, capitals on the columns and some of the tiled floor. It was copied, prior to the mutilation, on a canvas 1.70 x 2.16 cm, which is now in the Brera. The reduction in size has created a long narrow format, something over 2.1 m, and it is clear that our *Last Supper* was also reduced in almost exactly the same manner. We have also lost part of both boys and surely some floor tiles – since the lower details are too near the bottom of the canvas – and certainly the windows, both lateral and behind the figures.

Titian's original painting placed the figures far below halfway down the canvas, giving the architectural setting a much greater importance. It is not possible to know the exact size of our original painting but having noted that it was certainly reduced in size, I extended the shape to what would seem logical, including the sides, missing windows and arches, and some tiled floor. This would now create a proportion of figures to architecture similar to the Titian before mutilation.

We can only speculate on why this took place. It was prior to *The Last Supper* being bought from the da Mula family in 1775 and may well have been when it left the convent and arrived in the Palazzo da Mula. Given the painting was surely commissioned by the convent, they were aware of its new siting, so would not have

FIG. 8.10
Titian and his workshop
The Last Supper
1557–64
oil on canvas
109 x 214.7 cm
The Royal Monastery of San Lorenzo de El Escorial, Madrid

cut it down then. No documentation or physical evidence exists.

This is not really relevant to our sources but it is inconceivable that the reduction was influenced by the Escorial *Last Supper* reduction.

An interesting fact regards the signature on the Escorial painting. It is situated on the copper bowl on the floor, exactly as our signature is found on the metal jug on the floor. This is dated 1557–64 and the form of the letters is much the same as those on our *Last Supper*; that is, thin upper case letters with serifs, as is often found.

A further point relates to Titian's two *Last Supper at Emmaus*, painted in 1531 and 1535. The latter is in the Louvre and the finer in quality of the two. The face of Christ has the features which we find in many Titian's – including *The Tribute Money* (*c.* 1560–68), *Christ Blessing* (*c.* 1560) and *Christ and the Adulteress* (*c.* 1508–10) – and which we also find in our *Last Supper*. The format of these two *Suppers at Emmaus* is frontal but in the Urbino version of 1542–44 we find a diagonally placed table, possibly the first of its type, and as Wethey observes, 'one to have a long history in Venetian art, especially in the hands of Tintoretto. It makes a break with the long tradition, that of the horizontal table.'[9] There are also changes in iconography, most notably the position of John and the holding of the wafer, symbolising the origin of the Eucharist. We find the change more common after this painting, as the Reformation approached and it soon appeared in Tintoretto's work.

All the major painters of sixteenth-century Venice painted a 'biblical feast' painting, including Titian, Tintoretto and Bassano, but the Louvre *Supper at Emmaus* shows a careful study of Leonardo's *Last Supper* – the long table, a frontal view of Jesus, emphasised by architectural features (more obvious still in the Escorial work), the carefully observed folds in the tablecloth and the beautifully painted still-life groups of table items. Then, in 1542–4 in the Urbino *Last Supper*, we see the power of Leonardo's influence in the more eloquent poses. The Escorial version similarly has significant links with Leonardo in the longer table, figure grouping and psychological drama.

The eloquence and drama of the Louvre *Supper at Emmaus* is combined with the simplicity of Leonardo's composition to emphasise drama. We also find the use of the two young boys, now

a feature of Venetian art. Similarly, dogs begin to appear. Jacopo Bassano probably painted the first portrait of two dogs in 1548–9 and Titian took great care with details of animals. They and the boys could add levity to a sombre subject and Titian's portraits of boys are often humorous and spontaneous, counterbalancing a solemn scene.

How, then, is this study of Leonardo relevant to the Ledbury *Last Supper*? In just over a decade, Titian had moved on to themes which resounded into Mannerism and yet our *Last Supper* could not have been started much before 1560 but had reverted to the formal simplicity of Leonardo in many respects and Titian's own *Last Supper* of 1557–64.

The most likely simple explanation is that it was destined for a convent and they wished for a more traditional, simple composition.

Portraiture in a religious painting is a further reference to Leonardo. Our two apostles to the left are certainly portraits. Leonardo, like our painter, had studied real people and searched for the types he wanted to use. His faces are not generalised images. Titian similarly used people, often within his circle, as subjects in religious paintings.

Portraiture now had a special status in Venice and portraits of collectors, together with their artworks are found (for example, Titian's portrait of Jacopo Strada). Portraits of artists were of particular interest, not to say an obsession.

This new interest in artists' images is of especial interest in our *Last Supper* and we shall investigate this in Chapter 10.

1. Brant Pitre, *Jesus and the Last Supper*, Grand Rapids, MI: William B. Eerdmans, 2015, pp. 104-05, 283-4, 290-92, 316-20, 374-403, 406-11; Gertrude Schiller, *Iconography of Christian Art*, Greenwich, CT: New York Graphic Society, 1971, 2 vols, Vol. 1, pp. 117-21.

2. Pitre, op. cit., pp. 121-47; George Ferguson, *Signs and Symbols in Christian Art*, New York and Oxford: Oxford University Press, 1954; Liana De Girolami Cheney, 'Vasari's Last Supper; a thanksgiving celebration', *Journal of Cultural and Religious Studies*, December 2016, Vol. 4, pp. 735-78.

3. Gina Maruca, Karl Hammer and Gaetano Laghetti, 'Religious and Cultural Significance of the Citron (*Citrus medica* L. "Diamante") from Calabria (South Italy): A Biblical Fruit of the Mediterranean Land', *Journal of Environmental Science and Engineering*, 2015, pp. 203-09.

4. Dr Dafna Langgut, 'The importance of citron in religious ritual ...', *Science Daily*, 2017.

5. There is no authoritative documentation on the woods used in the cross. These beliefs tend to be restricted to the Catholic church and the Eastern Orthodox church.

6. De Girolami Cheney, op. cit., p. 13 for Abbess Antonia de' Medici, 1514.

7. P. Vinassa De Regny, *Dante & il simbolismo pitagorico*, Genoa: Fratelli Melita Editori, 1990.

8. Weiss, 'A note on the so called "Fides simulacrum"', *Journal of the Warburg and Courtauld Institutes*, 1961.

9. Harold E. Wethey, *Titian, The Religious Paintings*, London and New York: Phaidon, 1959 (2nd edn 1969), p. 96; Tintoretto's *Last Supper*, 1592–4, Church of S. Giorgio Maggiore, Venice.

9

THE WORKSHOP, 1548–80, IN VENICE AND EUROPE, THE VECELLIO FAMILY AND SOME ATTRIBUTIONS

We have looked at the workshops in a general sense and identified documented collaborators. We now need to look at dates and consider which painters were actually in a position to contribute and what documentation is available to substantiate the claim.

For many years Lionello Puppi studied Titian's correspondence across Europe and a considerable amount of vital information emerged, although much relates to commissions and the Vecellio business ventures rather than the names of collaborators. However, in 1548 Titian moved to Augsburg to meet Emperor Charles V, then returned again to Augsburg in 1550–51, and documents help us to understand what is called 'The Titian System'.[1]

We now find Titian working for the heads of many European countries. He was extremely wealthy; an astute businessman with many commercial interests and he ran 'a network of international relations'.

Workshops had expanded from Venice and painters of varying origin, type and background revolved around Titian. Some were continuous collaborators and others occasional. His family was constant, and others such as Polidoro and Dente were often in the shop, although now working independently as well. Individual identification becomes even more difficult from the 1550s onwards, given the development of the workshops.

Documentation now exists,[2] placing the young Polidoro in the studio of Bonifazio Veronese (Bonifazio de'Pitati) together with Tintoretto, Schiavone and Sustris before he entered Titian's workshop. They were all central figures in Venetian Mannerism

after the mid-century. Polidoro was then probably introduced to Titian by Francesco in the mid-1530s, whilst Polidoro had worked with Tintoretto on various occasions.

Bonifazio's workshop had a huge output and little is signed. He died in 1553 and attracted many important artists in their earlier days by his synthesis of Titian, Palma Vecchio and Giorgione, all in glowing colour and varying greatly from large compositions to small devotional images. He also looked beyond Venetian painting to central Italy and its own Mannerism, and his interest in collecting prints from van Leyden and Dürer to Raimondi's prints of Raphael must have made a big impact on his large studio.

These connections are discussed by Tagliaferro et al. Titian's inventions recur in Polidoro's work in compositions, motifs and especially Holy Family groups, and attributions have changed over time. Some Titians have been reassessed as Polidoro and occasionally the situation has been reversed. Some others have been reassigned to the workshop with a lack of name.

Once Francesco Vecellio became further involved in the supervision of business, he spent more time in Cadore towards the 1540s, probably having a studio there as well. Then, his earlier, more identifiable work within a Titian altarpiece became less clear as he was assisted by more collaborators from Titian's own shop. This caused an interchange of ideas which complicated the situation even further.

The significance of these early connections is important for our *Last Supper*.

Returning to the Ledbury painting, I conjectured in an earlier publication[3] that the it may have been completed on Polidoro's death in 1565. More recent discoveries show that its completion was later. At this point there was a huge demand for Titian's paintings and a veritable factory of images was produced in Biri Grande and Augsburg. Titian himself was often travelling, so occasional helpers and collaborators were vital and many were now within his orbit.

Titian established another workshop in Augsburg, having taken a group from Venice with him. He famously referred to feeding 'seven mouths' – probably an exaggeration, but Ridolfi tells us that Orazio and Cesare were present and he must have included more collaborators who as yet lack names. However, it

is possible that the family constituted his travelling studio and it was probably at this point that Emanuel Amberger joined.

This first trip to Augsburg was important in that it altered the structure of Titian's organisation. Titian had carefully planned a prestigious position for himself but the influx of new commissions required a guaranteed support away from Venice and therefore he took his family and some unknown others.

Meanwhile, at Biri Grande Francesco took over the workshop. He was much involved in business and town administration, and he administered the Vecellio affairs. His own work demonstrates an ability to orchestrate a large figure composition. Francesco died in 1560 but Orazio had already visited Rome with his father in 1545 and he was becoming an important part of the Titian business. The few paintings which may be attributed to Orazio indicate a continuity with the Titian tradition and only one of a number of portraits remain.

Early criticisms of Orazio are confused and only in the nineteenth century did studies begin to evaluate him more positively, with Cavalcaselle and Crowe. Later, there were more negative reactions to Orazio's importance, after which Matteo Mancini and Lionello Puppi gave a more accurate account. Considerable documentation has now been discovered, although much related to business affairs. This was inevitable after 1560 and Francesco's death.[4]

Titian was now clearly inclined to develop Orazio's prestige in the eyes of the royal courts who sought Vecellio's work. One such example is Orazio's small *Crucifixion* in the Escorial, which Titian sent to Philip II. My own feeling is that Titian could well have worked on the painting himself, as he often did, since this introduction to Philip II was decidedly important. So are we seeing an Orazio autograph work? I personally suspect not and, regardless, I see little of our *Last Supper* in the freedom of this panel. However, sufficient evidence of Orazio as a portrait painter means that we must consider him a possible painter in our *Last Supper*. A little before 1557 Girolamo Parabosco wrote to Orazio congratulating him on the execution of 'the beautiful portrait of one of his mistresses'.

At this point, portraiture was developing into a large part of the Vecellio shop. Like Girolamo, Orazio and Marco were producing

Fig. 9.1
Orazio Vecellio
The Crucifixion
1559
23 x 17 cm
The Royal
Monastery of
San Lorenzo de
El Escorial, Madrid

their own work as well as having to consciously collaborate with Titian and be indistinguishable from him. There is little research on the possibility of collaboration between themselves but there is some evidence, and whilst it may not be relevant in our *Last Supper*, it serves to remind us that these were men who worked together in the studio on a regular basis.

The discussion on Orazio's work is ongoing and the frequent praise of lost portraits suggests that this was Orazio's

specialisation. Even Vasari, who met Titian and Orazio in Rome in 1545–7 praised Orazio's work, although the subject matter to which he referred is uncertain, as are other possible attributions. The only signed Orazio painting, seen by Francis Russell in a private collection, was noted for its 'high quality – worthy of Titian'. It is dated to the 1560s and therefore it is plausible to consider that Orazio worked on our *Last Supper*. Although there is a suggestion of more portraits from an earlier decade, this portrait of a man shows a virtuosity worthy of Titian and a complexity of handling.[5]

When Francesco died in 1560, Orazio became more important in the workshop, receiving commissions. He was promoted by Titian and also held a central role in the Vecellian timber and property business.

Marco, Orazio's cousin, was born in 1545 and documents indicate that he worked with Titian from 1565. He could then have been a close collaborator during the last decade. Little is known of Marco's commissions until after Titian's death and similarly Cesare Vecellio, born in 1521, was involved in the studio.

We have now looked at the botteghe in sufficient detail to at least consider who could have collaborated in our *Last Supper*. There are other young painters, such as Natalino da Murano, Girolamo Pellegrini, Lorenzino and Pietro Rosa, together with more names without paintings – or with few – and we have no documentation to include them.

Emanuel Amberger, was, as we have seen, a major contributor and he was documented after 1573 as living at Biri Grande but mentioned as a favourite assistant in 1568. He may well have joined in 1561/2. Much of the information on Amberger derives from Puppi's research of letters and we see in them various references to the German. The famous Titian letter to Jan Hans Fugger mentions 'have a Tedescho at home, Emanuel' in 1568. We know Marco and Amberger were also at Pieve di Cadore in 1565–8 with Titian and Zuccato, and Amberger painted a (lost) banner in Serravalle in 1578, but other than a small drawing we have no positively identifiable work by him. As Biffis and Tagliaferro also point out, however, he was very important in the workshop and was possibly a specialist in gonfalon banners.

Whilst there is no signed Amberger painting, one tends to assume it resembled his father's work, Christoph, with fine well-

observed detail. In fact, there is a painting in the Royal Collection, *Portrait of a Man*, which was attributed to Emanuel Amberger in 1838. Since then, Blunt, Penny and others must have examined it and not disputed the attribution. We certainly see a Titian follower in the pose, landscape and technique. The man is holding a book, which has been suggested links with Amberger's uncle, who was a bookbinder, but books were a very common iconographic image so I feel that is a doubtful connection. The style is reminiscent of late Titian with a freedom of brushstroke and what appears to be a green earth ground. Whilst this is an interesting painting, if we are to assume we are looking at Amberger's work then it bears little resemblance to our two portraits in the *Last Supper*. However, we must remember that Amberger worked closely with Titian for more than a decade and was perfectly capable of moderating his style to blend with a Titian or workshop painting.

Vast quantities of Titianesque work exists; some from the botteghe, some containing the hand of Titian and some from artists in Titian's orbit. Those which show consistency of manner, common models, faces, iconography, and so on may be attributed to the workshop.

Our primary concern is attribution and that requires an examination of the workshop artists' ability to produce highly competent portraits. In fact, Titian's workshop donor images are excellent and those we are considering are Francesco Vecellio, Girolamo Dente, Orazio Vecellio, later Marco Vecellio, a visitor in the form of Polidoro da Lanciano (who now had his own workshop), Emanuel Amberger and helpers Valerio Zuccato who died in late 1576 or 1577 (brother of Titian's old friend Francesco Zuccato) and Giovanni Maria Verdizotti. Then, after Titian's death we have evidence that Palma il Giovane was completing Titian's *Pietà* and know that Tintoretto visited the workshop in 1576/7.

Some sources state that both Palma and Tintoretto trained with Titian for a short time. In Palma's case it was probably because he is documented as completing Titian's *Pietà* after his death, thus suggesting an earlier connection, but there is no documentary evidence of this. Tintoretto was popularly thought to have trained very briefly before tiring of producing Titian copies, as we have seen, but again there is a lack of evidence. Given the various early references, it does seem likely he was in

the workshop for a short time. In fact, there are no signed and dated early works by Tintoretto.

Examples of workshop portraits are Polidoro's portrait of Simone Lando and Francesco and Dente's work on the Monopoli Altarpiece. Orazio's *Adoration* of 1566 at the Calalzo di Cadore, with its two beautifully observed heads, recalls our apostle in red portrait. His signed *Portrait of a Man* of 1560–65 and the range of expressions in Dente's *Annunciation* of 1557–61 or his *Assumption* of 1564, which contains many portrait heads, all indicate that Dente was a highly accomplished painter.

Tagliaferro et al commented on the Calalzo paintings: 'Rapid thin and compact layer, fused brushstrokes and with a limited use of superficial glazes and touches of white.'[6]

They also relate Orazio's technique to that of Marco Vecellio. I have not personally examined the Calalzo Doors, and detailed images seem fugitive.

So, in the seventh and eighth decades of the Vecellio shop we have a small group of collaborators fixed in Biri Grande with visiting help and some travelling in addition. Dente was probably no longer permanent and had his own studio with private work, including the Spanish Court in 1564, but he certainly contributed until that date. He also independently painted the Doge Lorenzo Priuli, a very important private commission, doubtless via Titian, but this was destroyed in a fire in 1577 together with other paintings relating to the doge.

It is likely that with Marco and Orazio in the workshop, Dente was no longer required. There are tales as to why he moved on, but most importantly for our research he often signed his work and this is highly significant.

Zuccato was essentially a mosaicist, and an example of Titian still using external artists. He may also have painted but there is little evidence as yet.

Giovanni Maria Verdizotti was thirty-three in 1570 and was primarily a noted literary talent, reported by Vasari and mentioned by Ridolfi. He did some drawing but there is nothing to positively connect him with the Ledbury *Last Supper*.

Similarly, Marco was sufficiently competent to work on some of our painting and Cesare Vecellio, Titian's cousin, played a part in the early workshop, accompanying Titian to Augsburg in 1548,

but by 1570 he was more active as a publisher. His large family portrait of 1560 shows some competence but there is a stiffness to the forms and a lack of character to the faces. However, his *Last Supper*, also of 1560, shows considerably more life. The architecture and setting is obviously based on Titian's *Last Supper* of 1557–64, on which Cesare could have worked. It was certainly in the workshop when Cesare was there. The figure grouping is different from the Ledbury painting, as is the format. What is of particular relevance is Cesare's apostle on the right with raised hand. Our painting has a very similar pose and his gown is similarly used to create a flow of movement across the front of the picture. I have been unable to find another Last Supper image which is comparable, and since we know Cesare was in the workshop during part of the 1560s, until he developed his printing interest, his invention must surely have been seen by Titian and used in our picture. Titian frequently used the inventions of others and it is difficult to establish the artist himself, but the figure could well have been painted by Cesare. Its precise dating is discussed in Chapter 7.

After Titian and Orazio died, the bottega was closed. There was then a burglary and many valuables were looted and paintings taken. At this point Tintoretto visited the workshop and acquired some paintings whilst Amberger is documented as completing unfinished work with Marco, Verdizotti and Palma il Giovane, supervised by Pomponio Vecellio, Titian's other son.

By this time, Polidoro had long since been dead (1565), Dente died in 1562 and Orazio was to die a month after his father, in September 1576. He could, in theory therefore, have painted at least one of the portraits, particularly when we consider the expertise we see in the Calalzo *Adoration*, although the two heads do seem something of an anomaly in Orazio's work.

We have, then, a large, commissioned *Last Supper* in the workshop in 1576. It had remained at Biri Grande since, probably, *c.* 1560 and I believe it contains the work of Francesco Vecellio, Marco Vecellio, Polidoro da Lanciano, Girolamo Dente (who may well have had a part in the idea of adding the two boys), Orazio Vecellio and a number of assistants and helpers. It was composed by Titian and his brother, Francesco, both of whom, or Titian alone, drew out on the canvas freehand, possibly following a simple transfer.

After Titian's and Orazio's death, the collaborators had to complete many paintings. There is scant knowledge of these but an inventory was drawn up, although it is as yet untraced, and a legal battle ensued involving various members of Titian's offspring. The long dispute was between his two daughters, Lavinia and Emilia, with Pomponio acting for the latter and trying to prevent Lavinia's husband, Cornelio, claiming the entire estate. Titian was extremely wealthy and famous by this time, with a large family, and a settlement was finally reached, but many paintings were still in the studio as we noted and between accusations of theft on each side and the looting of Biri Grande there is no accurate record of the remaining paintings.

We have documentation to show that the work continued until certainly 1578 and possibly 1580, and the Ledbury *Last Supper* was still unfinished and in the workshop due to huge pressure of work. In fact, as previously noted, it was very common for work to be put aside in Titian's workshop as more important commissions arrived. The frequent travels of Titian and his assistants delayed work even further. Documents state that several large altarpieces were still unfinished in the workshop, and our *Last Supper* was obviously one of these.

This may be a relevant point to quote Palma il Giovane's account of Titian's working methods, in that it confirms the practice in the workshop of Titian turning his paintings to the wall and leaving them for some months. It seems highly probable that the workshop would adopt a similar method as well as simply giving preference to more important – for example, royal – clients. Palma describes Titian laying down a mass of colours first, then 'having constructed these precious foundations he used to turn his pictures to the wall and leave them there without looking at them, sometimes for several months. When he wanted to apply his brush again he would examine them with the utmost rigour … to see if he could find any faults.'[7]

In 1576/7, Palma il Giovane is recorded as completing Titian's *Pietà*, intended by Titian as his memorial. Amberger was surely involved in this work, since he was paid until 1578. Some evidence places Palma in the bottega in the early days but we have no specific dates. It is probable that Palma also met Tintoretto and Polidoro at this time. Nevertheless, we have Palma il Giovane, the most

celebrated painter in Venice after Tintoretto's death, together with the visiting Tintoretto, assorted helpers and Amberger all in the workshop.

The two portraits were, then, painted in 1576. We have no drawings or documentation, so cannot know if they were originally intended as portraits of specific people but it is doubtless that they became so. But who are they? Does the fact that that each shows a marked similarity to Titian and Tintoretto give us a clue? We shall examine this again in our hypotheses in the next chapter.

1. Antonio Paolucci, *The Titian Firm*, Rome: L'Osservatore Romano, 2010; G. Tagliaferro, B. Aikema, M. Mancini and A.J. Martin, *Le Botteghe di Tiziano*, Florence: Alinari, 2009.

2. Robert Echols, *Tintoretto, Artist of Renaissance Venice*, New Haven, CT: Yale University Press, 2018.

3. Ronald K. Moore and Patricia Kenny, *The Ledbury Last Supper, a discovery and a mystery*, Ledbury: The Friends of Ledbury Parish Church, 2018.

4. Lionello Puppi, *Su Tiziano*, Milan: Biblioteca d'Arte Skira 11, 2004.

5. Tagliaferro et al., op. cit., p. 200.

6. Tagliaferro et al., op. cit., p. 208.

7. Francesco Vancanover, 'An Introduction to Titian', in *Titian, Prince of Painters*, eds Susanna Biadene and Mary Yakush, Venice: Marsilio Editori, 1990, pp. 23-4.

10

HYPOTHESES FOR
THE PAINTING OF
THE TWO PORTRAITS

We have considered all the artists who were potentially involved in the Ledbury *Last Supper*, and we have established a precise time period when our two apostles were painted and who was in the studio in early 1576 to 1580. We have also established that they were painted during 1576, having found a small date and explanation of its significance in Chapter 4. Titian died in August 1576 and Orazio a month later. We now have to look at the possible painters of the two portraits and assess which artist, within that small group, would not have painted them and then who remained that could have done so. We have clear documentation as to who remained at Biri Grande over this time, so one of the following hypotheses should be correct.

Before Titian's time it was not considered a social necessity to have one's portrait painted. By the mid-century most of the European aristocracy and royalty wanted a portrait and they wanted it to be painted by Titian, who was now not only the most sought-after painter in Europe but also one of the most famous people in Europe.

He had worked for many noble families, from the Duke of Ferrara in his early years to Philip II, for whom he worked until he died. He painted a wide range of subjects for Philip and, significantly, he used a more 'finished' style than in many of his own paintings. This is especially seen in one of his very last works, *The Death of Actaeon*, which we cannot know whether Titian believed was completed or not. The same applies to the *Pietà*, certainly unfinished on his death, where we find a

FIG. 10.1
Close-up of
second apostle
from the left

whole new painting technique seen throughout much of his
late work. Now we have little of the earlier grounds, built-up
layers and final glazes, but rather we see Titian ranging all
over the canvas, employing glazes at any point and following
no specific modus operandi. In the early nineteenth century
his sketchy style was noted by art historians and often his work
was described as unfinished but it was far more than this.
However, for this study we may note that Titian was capable of
varying his technique, as he did in the portrait of Philip II and
we cannot, therefore, totally exclude his hand in our painting
simply because it is not typical of some of his work of the 1570s.

A further point is the way in which Titian's portraits have a life and power and look out at us – in the manner of our apostle with the black beard.

Titian was clearly experimenting by this late period and it seems likely that *The Death of Actaeon* was in fact finished, but the point is that he could change his style.

1. There is evidence of lost glazes on the man with dark beard, both on his face and on his robe. This has undoubtedly changed the perceived style of painting. The ground paint remaining could have been painted by Titian early in the year (he would have included glazes and flecks of high tones for highlights.)

The freehand drawing discernible around the figures – as opposed to a tracing – the major changes in design in that area and two heads and figures being moved all suggest a decision made by a master rather than an assistant.

The portrait bears a strong resemblance to Tintoretto. Overlaid computer images show very similar features

FIG. 10.2
Second apostle
from the left
and Tintoretto
self-portrait
comparison
1548
oil on panel
45.7 x 36.8 cm
Victoria and Albert
Museum, London

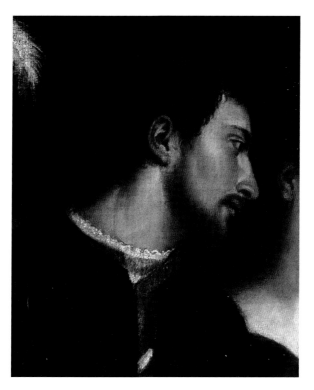

FIG. 10.3
Titian
*Self-portrait
with Friends*
1550–60
Louvre Museum,
Paris

matching Tintoretto's 1548 self-portrait. However, given the lack of sympathy between the two painters, it is unlikely that Titian worked on this head.

The left portrait bears a strong resemblance to the young Titian when we compare it to his *Self-portrait with Friends* (1550–60) in the Louvre, also with distinctive red beard and hair, and the Prado *Self-portrait* (*c.* 1562), as seen in our comparison photographs. A painter's portrait would be very much in the tradition of Venetian art at that time and Titian was still in the studio until August, although ill, even before contracting the bubonic plague.

We have completed careful computer comparisons of the profiles of our Ledbury man and Titian's Madrid self-portrait, overlaying the images, comparing details of ears, nose, and so on. This was helped by using facial recognition software used by the security forces. The two match perfectly and we believe that we have a portrait of the young Titian. The most likely painter would be Orazio Vecellio, Titian's son, painting early in 1576.

We have evidence of Orazio's skill in portraiture in the 1566 Calalzo di Cadore *Adoration of the Magi,* and he was often noted as a portrait painter, although much of his work was lost in the Palazzo Ducale fire of 1577.

The other painters in the workshop were Amberger and Palma il Giovane, and the 'Titian' head is unlike the work of either.

2. The painting was incomplete on the death of Titian and Orazio and it was completed by one of the visitors. Pomponio Vecellio, Titian's son, was organising completion for around two years. Marco and Cesare Vecellio had insufficient skill for our portraits, but we then find Amberger documented as completing paintings and Tintoretto in the workshop 'acquiring paintings'. Tintoretto may have worked with Titian briefly at the same time as Polidoro in the early days, but he did come to the workshop *c.* 1577. Whilst there, was he asked to help complete the portrait? Why was he there at all? Did he 'acquire' his Titian paintings legitimately (there was the burglary to consider) or were they in payment for work on *The Last Supper*? Perhaps the last point is unlikely.

Is the portrait second from the left a self-portrait or a portrait of Tintoretto? We have noted the marked similarity between our man and Tintoretto's self-portrait (Tintoretto was twenty-eight years older than in his 1548 self-portrait when he was thirty. If he looks a little younger, then he could well have presented himself so.) Moreover, this powerful image looks at us straight out of the painting, a feature usually reserved for an artist painting his own portrait.

Is this similarity to two major artists in both heads, in the same painting, sitting adjacent, painted in the same year, 1576, to be taken purely as coincidence? The fact that the man with the red beard is surely Titian lends weight to the other portrait being Tintoretto, who would have been painted by Palma, Amberger, Orazio or Tintoretto himself. The style is unlike the Titian head by Orazio, nor is it like the fine technique of Amberger.

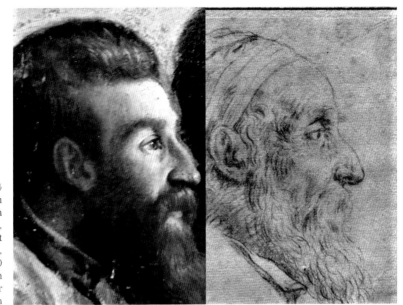

FIG. 10.4
First apostle from
the left and Titian
comparison,
Titian self-portrait
drawing,
1560–70
black chalk on
ivory paper
120 x 99 cm

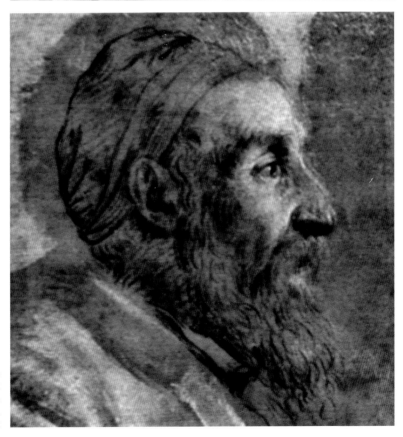

FIG. 10.5
Overlay of first
apostle from the
left and Titian
self-portrait

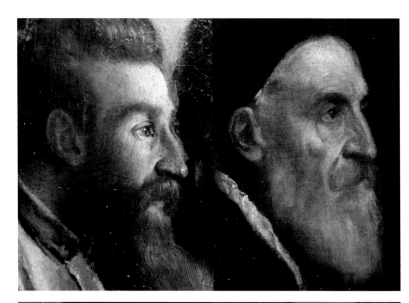

FIG. 10.6
First apostle
from the left
and Titian's
self-portrait
c. 1562
oil on canvas
86 x 65 cm

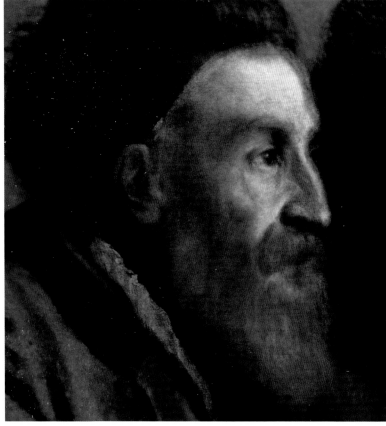

FIG. 10.7
Overlay of first
apostle from
the left and
the Titian's
self-portrait

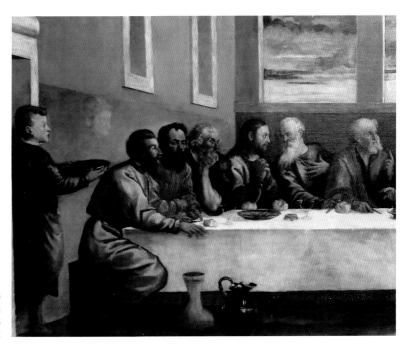

FIG. 10.8
First to sixth
apostles
from the left

3. Palma il Giovane was completing Titian's *Pietà* (now in the Accademia) in the workshop. The Duke of Urbino had sponsored Palma to study in Rome from 1567–72, after which he returned to Venice. He was certainly at Biri Grande after Titian died and was already a portrait painter of remarkable ability, in addition to developing his own Mannerist style under the influence of Tintoretto. At this time he was aged twenty-eight and he must have seen the huge *Last Supper* in the workshop. Moreover, Tintoretto and Palma would surely have discussed the incomplete altarpieces and Palma most certainly had the skill to paint our 'Tintoretto' head. Would it be so surprising that the young, brilliant Palma who studied Tintoretto's work closely and the mature master painter of Venice came together briefly in the curious situation of being in the dead Titian's studio and agreed on a final collaboration? Could Palma, painting the 'Tintoretto' portrait, have taken advantage of the great Mannerist painter actually being there with him in the workshop? Once again, we have a remarkable coincidence if this is not the case.

It should be said that although Palma was in the workshop and he could well have contributed to our painting, the studio

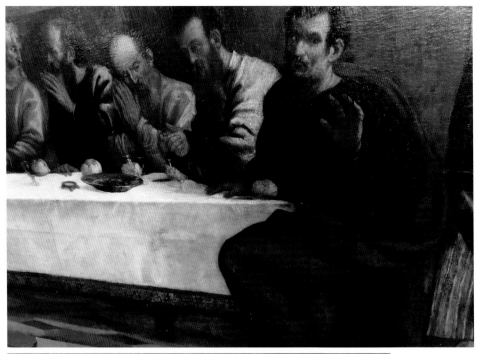

FIG. 10.12
First to fifth
apostles from
the right

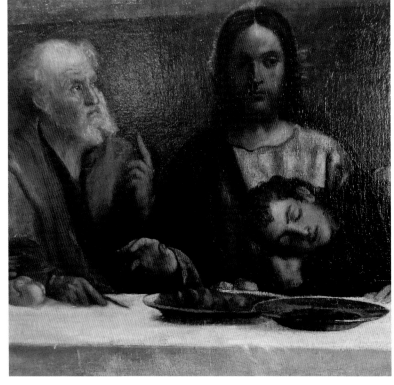

FIG. 10.13
Sixth apostle
from the left,
Jesus and John

was still full of unfinished work. This picture is essentially a workshop piece rather than one primarily by Titian's hand such as the *Pietà*. Would Palma, a highly accomplished artist, have wished to add to it? He possibly had an early, undocumented connection with Titian and now found himself in Titian's workshop with Tintoretto.

4. Emanuel Amberger worked with Titian from 1562 and was then in the workshop completing paintings. As we have seen, little of his portraiture ability exists, but there is sufficient to seriously consider him as one of our painters. The most probable would be the Tintoretto head, but whilst we know of his presence we have no documentation or comparable work to make an informed assessment.

11

CONCLUSION AND HYPOTHESIS FOR THE CREATION OF THE LEDBURY LAST SUPPER

The large commissioned Ledbury *Last Supper* was begun *c.* 1560 and remained at Biri Grande for some eighteen to twenty years. It bears the signature of Tiziano Vecellio and this small inscription, with an illegible fragment of date below, is perfectly compatible in style with some other Titian signatures in his own hand.

There is no doubt that the painting originated in Titian's workshop and more than 10,500 hours of exhaustive research have led us to make some sound conclusions. Without full X-ray analysis of the entire canvas, I do not believe more information can be achieved.

It is vital to remember that this painting has suffered considerable damage through careless restorations in the past and there is no doubt that a top layer of subtle glazes, and probably highlights, have been lost. This does not make individual attributions easier.

First, the composition and initial concept was by Tiziano and Francesco Vecellio, if they received the commission in the late 1550s, before Francesco died. If it came after 1560, the sketches, composition and drawing-out would have been primarily completed by Titian himself, since the thirty-two-year-old Orazio could not have organised a work alone on this scale in 1560. Girolamo Dente almost certainly contributed to aspects of the initial composition.

Secondly, the fact that Titian's signature matches others in his hand informs us that he must have played some part in the painting. There is really no part that one can confidently say

bears Titian's brushstroke. We have to deduce, therefore, that he must have been instrumental in the composition and certainly some of the underdrawing.

We have already considered the spolvero/tracing aspect of the drawing-out, yet none is discernible. However, we have found traces of bold underdrawing in places.

There are also many small changes, large alterations and touches of paint added to the initial design of the figures. Titian was noted for this process – adding touches and making small changes before signing his name.

Third, we have, primarily, a Titian composition which was at least partially drawn-out by Titian and we have identified Polidoro da Lanciano and Girolamo Dente as completing parts, together with helpers such as Zuccato and Verdizotti who would have worked on the background, table, clothes, and so on. Given that even from the time of Vasari it has been impossible to differentiate between the various assistants, we cannot be absolutely certain of all the individual hands.

However, after considerable study and reflection, my hypothesis is as follows and is based on an examination of the many paintings produced by the workshop painters.

Four apostles with grey beards clearly stand out as being of higher quality, observation of character, bold brushwork and a consistency of style, although the one next to the 'Tintoretto figure' is more accomplished. Based on examples of his work, and especially *The Four Seasons*, together with the fact that we have his monogram on the wall, we may attribute them to Girolamo Dente, painted 1560–64 (the date of the monogram).

The fourth apostle from the left, in red lake, and the group of three on the right all have a consistency of style, with the exception of the figure with a raised hand. My hypothesis for at least some of these four apostles is Polidoro da Lanciano, as we can find similar models, comparable brushwork, treatment of beards, hands and drapery in his work. It is unlikely that the clothes were completed by the same painter who worked on each head and certainly not in the case of the two apostle portraits to the left of the canvas. However, we do find some of the gowns in figures painted by Polidoro elsewhere have precisely the same use of lead white and red lake as we find in this *Last Supper* and, not surprisingly, this is

often found in the work of Titian (for example, the Madonna in *Madonna con il bambino S. Pietro che presenta il donatore Simone Lando*). Similarly, the multitude of hand gestures in our *Last Supper* recalls Polidoro's *Discesa dello Spirito Santo*, his only inscribed painting dated MDXLV (Galleria dell'Accademia).

A version of *Cristo e l'adultera* in Brescia (1545/50, Pinacoteca Tosio Martinengo) and especially the *Lavanda dei Piedi* (1545, Staatliche Museen Gemäldegalerie, Berlin) provide us with, perhaps, the nearest similarities in brushwork, composition and types (although there are no specific models other than, probably, the kneeling Christ and our fourth apostle from the left in red).

Some of the apostles' gowns in the *Last Supper* have a more heavy impasto style of paint and lack the subtle glazes of others. These were surely completed by helpers in the workshop.

The apostle to the right, with raised hand, was most probably an invention of Cesare Vecellio and is seen in his own *Last Supper* of 1560. Since we know he was present at this time, it seems likely that he would have worked on the figure. The face is damaged a little and the robe much repainted, so identification of the man and the painter are challenging. The figures of Christ and John have some loss of glazes and have surface damage. It is possible that they were also painted by the same visiting workshop assistant who may have been Polidoro da Lanciano. We have to also recall that Marco Vecellio was in the shop at this time and is very likely to have worked on the *Last Supper*. The Christ and John figures are somewhat different in technique but Marco's ability was, at times, higher than we see in these two faces.

My primary reason for this hypothesis is that two of the apostles in the right group, second and third from the right, have very obvious pentimenti having been changed. The alterations were certainly by the same painter and indicates a creative process. This is very unlikely to have been the case were they painted by an unknown assistant, but Polidoro was not a full-time helper at this time, as he had his own studio, so Titian would know he was capable of creative decisions. However, Marco was similarly highly able to produce excellent portraits. I feel that a completely positive attribution is not possible at this time.

We have to again remind ourselves that Vasari, who knew Titian and the workshop, was unable to determine the various

hands involved in a workshop painting. This problem is unchanged today.

We have lists of artists from Vasari onwards who worked with Titian, but often in their own workshops as well. Frequently, we are able to assess a body of work by painters like Polidoro, Peterzano, Sustris, Schwarz, and so on, who developed their own style outside Biri Grande but helped there for some years. The real problem lies in the long-standing workshop helpers, who were highly adept at working in the style of the master and the earlier assistants such as Polidoro, who could change their methods in their own studio but return to successfully assimilate with Titian again. One aspect of the Titian workshop problem is certainly determining who developed independently and created an identifiable artistic language removed from that of Titian.

The more complex problem is trying to determine the contribution of an assistant. Documentary evidence is often very limited and we can then only rely on close examination of brushwork and painting technique. It is possible that X-ray analysis and scientific examination of underdrawings and pigments would reveal more of these assistants but, as has been noted earlier, all the materials and pigments were easily available and we may be certain that those in Titian's workshop were more or less consistent. There has been no complete analysis of the workshop of probably the greatest genius in European art, although the National Gallery did produce an excellent analysis of the work of Titian's paintings in London. We have to ask why the workshop has never been fully investigated, since suitable scientific techniques have been available for more than half a century.

The recognition of those assistants who produced repeated images in the shop has proved highly problematic. The Ledbury *Last Supper* clearly has five helpers or perhaps many more involved. I believe that despite the passage of time and scientific examinations of the London Titians, the accurate recognition of any Titian school of work such as our *Last Supper* remains fraught with difficulties, and having examined the Ledbury *Last Supper* for several months, it is difficult to see how a systematic examination of Titian's workshop assistants could be achieved.

Our final hypothesis and attribution relates to the four portraits: the two boys and the two apostles to the left.

The right serving boy is a portrait, shown by the changes made to the face. The painter is also perhaps one not yet encountered on our canvas, with his grey-green underpaint and thin glazes, many of which are now lost. The craquelure pattern is also different from any of the Polidoro and Dente faces. The cracks are closer and in a random all-over pattern with none of the vertical continuous lines seen, for example, on Christ's face. There is a thicker gesso ground and so less canvas texture to enable the painter to work in more detail. The hair is very well observed and finely painted, and the nose, eyes and ear have all been moved, indicating that we have a portrait. This is further shown by the fact that the boy is looking out at us, although some of the subtlety of the face is now lost. The ruff on both boys was painted by the same artist, the clothes on each by different hands and the heads were painted prior to the clothes. This all suggests that both boys were painted at the time, although by different members of the workshop. At this time I am unable to offer a name or subject for this delightful little portrait but feel it is one of the Vecellio family as a boy.

We have no way of knowing what happened next, but a probable scenario is that the painting was then abandoned as more important commissions arrived. Work recommenced in 1576 either just before or just after Titian and Orazio died.

The boy to the left may well be a portrait of a young Marco Vecellio, as our overlay of images and tracings indicate (the Marco portrait is from the London National Gallery painting by Titian, *Allegory of Prudence*). The style of painting is not quite like any other head in the *Last Supper* and given that Marco was present and that it may be his portrait, I suggest that he would probably be the painter. There are few comparable examples of his work to be certain. Close examination of this profile show old overpaint over a little of the nose which has changed its shape slightly. Traces of the original outline can be determined under magnification and they match the Titian portrait of Marco.

It should be noted that all those identifiable are painted as looking younger than at the time of the painting, and it is reasonable to suppose that the right serving boy is similarly a family member. The other remaining family members in the shop at this time were Cesare Vecellio and Pomponio Vecellio, and whilst we have no images of them as boys it seems quite

reasonable to think that the boy on the right could be Pomponio, since there is now more indication that this *Last Supper* may be partially interpreted as a family portrait.

My hypothesis for these late changes and the more noted pentimenti in the painting is that during this dire time of the worst plague which Venice had encountered, a decision was made – probably by Pomponio and Marco – to change some of the heads or perhaps they were not even completed as yet. The remaining unfinished figures then became the last Vecellio family portrait. The fact that five figures were changed prior to the addition of the two astonishing portraits on the left tends to lend weight to the argument that we are seeing portraits and with three or four Vecellio members in the shop, one has to ask, who else would they be?

Perhaps Orazio had commenced the idea if he painted Titian in 1576, or if he did not and had died, then Pomponio, organising completion of the many unfinished paintings and altarpieces, instigated the plan and a visiting painter was assigned to the Titian portrait.

I propose that the fact that one portrait is of Titian himself strengthens the hypothesis of the two boys and further indicates that the superbly painted apostle with black beard is also linked. This link is Tintoretto, whom we know was also in the shop (comparative computer images show similarities despite slightly different positioning).

Returning to the various possibilities in the previous chapter, we have to consider that we have Tintoretto and the brilliant young portrait painter Palma il Giovane together in Titian's workshop at the same time. On discovering himself in this situation and his old rival now gone, might Tintoretto have thought it be interesting to be included? The fact that the two painters are sitting together is surely significant. We cannot know what Marco and Pomponio instructed to happen at this crucial time of the Ledbury *Last Supper* unless documentation appears one day, but clearly it was being completed during late 1576–8 (although Amberger was still being paid until 1580, possibly working on other paintings).

Regardless of the painters themselves, I believe we have portraits of Titian, perhaps Tintoretto, Marco Vecellio and probably young Pomponio or Cesare if the apostle to the right with raised hand is not Cesare as an adult. This is surely a

portrait as evidenced by the figure's various pentimenti and its relating to us, the beholders.

As regards painters, I propose that we have a very rare, previously unknown portrait of Titian as a young man painted by Orazio, his son. (The other early image of a young Titian is his *Self-portrait with Friends* in the Louvre, 1550–60, with very clear similarities, and we have looked at computer overlays of our apostle and a painting of Titian in old age already.)

I propose that Palma il Giovane painted the possible Tintoretto head (assuming it is not a self-portrait), whilst Marco and the right serving boy were painted by two different artists. Those capable and present were Marco, Amberger and Palma il Giovane, so two of them seem likely to have been responsible.

As regards the seemingly unlikely juxtaposition of the two rivals in Renaissance Venice – Tintoretto and Titian – we have contrary evidence in Veronese's *Wedding Feast at Cana* (1562–3) in the Louvre, where we find the two painters represented together. However, the original identification of the various figures in this huge work was by Boschini in 1674, long after the demise of the many characters he purported to recognise. Scholars also differ as to which is Tintoretto, although it may be the figure behind Veronese, also playing the Viola da braccio.

The crucial point to note regarding our two portraits is that Titian was certainly not painted from life. This is a portrait painted, I propose, in retrospect, in the first half of 1576 by Orazio Vecellio, Titian's son, who never saw Titian at this age. Titian is represented at approximately thirty years of age and this would date the image to *c.* 1520. Orazio was not born until 1528, but he used his imagination, supreme painting skills and certainly observed the old, ill Titian in the earlier part of 1576 when Orazio was forty-eight and Titian probably eighty-six years old.

The *c.* 1562 Prado Titian self-portrait depicting the master at seventy-three to seventy-five years of age was still in the workshop for reference in 1566, since Vasari saw it in situ. This suggests that it may have been intended for his family. It seems highly probable that the self-portrait drawing which is used in our overlay comparison was also in the studio. As is very evident, the profile and ear match our painting of young Titian despite the representation of some fifty years' difference in age.

The use of a profile was rare in portraits and only occasionally used by Titian to represent deceased subjects. Profile self-portraits are exceptional, partly due to the problems of arranging mirrors accurately. However, the profile was also a concept of fame and the idea was revived from Roman coins, cameos and medals, and had explicit classical resonances. The profile form creates a detachment and monumentality which reflects how Titian saw himself: the great Venetian painter, treasured artist of the crown heads of Europe and centre of a group of the best writers and intellectuals. Titian had already been depicted in this form by Leone Leoni in 1537 and by Pastorino de' Pastorini in 1546, and was sharply aware of its importance.

The drawing was 'a project both personal and professional, aiming at creating an image of oneself to be left to posterity'.[1]

The fact that the young Titian portrait in the Ledbury *Last Supper* is similarly depicted in profile is highly significant. The painter, very probably Orazio, would have wished his father to be seen with the connotations of his past intellectual circles and references to fame. Titian carefully considered his image in his Prado *Self-portrait* and it is logical that Orazio would do likewise.

The black chalk drawing itself was only discovered in 2002 in the United States and after much careful examination was declared to by the hand of Titian. Its remarkable qualities have been discussed in the various exhibitions in Italy at great length.

That which concerns us now is how we found the drawing to be crucial in the identification of the first apostle on the left, proposed as Titian *c.* 1520.

The Prado self-portrait is not quite a profile, although it aligns with our apostle extremely closely.[2] The Berlin self-portrait is of course a three-quarter pose. The drawing is a perfect profile, as is our man and now we find perfect positioning of the ear and profile shape together with an entirely similar ear form.

The comparisons of the paintings and the drawing when overlaid are achieved by creating images which are opaque. The opacity was attempted in different proportions before determining the most effective which still showed both pictures. The drawing in the overlay has been darkened to prevent the delicate lines being lost against the painting, but the original may be seen in a different image.

The character of this small drawing (12 x 9.9 cm) has a remarkable power of expression and bearing, indicative of a work made from life. It seems certain that Orazio used the concept of the drawing to gain inspiration for this final painting of the great artist, his father who may have still even been alive at this point.

The alternative attribution would be Palma il Giovane, Amberger, Cesare Vecellio, Pomponio Vecellio or Marco Vecellio, the documented painters present. The face is far above Marco's ability if one compares it with his portraits and the style is dissimilar, whilst we know little of Amberger's portrait competence. However, we do know Amberger was in the studio and he may well have worked on the *Last Supper*. There is a continued paucity of information on these relative contributions.

If the Tintoretto portrait was painted by Palma, he did not work on the Titian portrait, as the two exhibit different brushwork and techniques. Some workshop assistants, such as Zuccato and Verdizotti, must have continued to complete the many unfinished works but none had the sufficient expertise for the Titian face. The same applied to Pomponio and Cesare.

We thus return to Orazio Vecellio as being the most likely painter of his father, Tiziano Vecellio, represented as a young man. A further compelling argument for this is the use of the profile, its indisputable significance when related to Titian, the implications of the import of the drawing and of course the conspicuous similarity of the drawing and our apostle.

CONCLUSION

We have, then, an indisputable *Last Supper* from Titian's workshop. We have documentation stating that it was purchased from the da Mula family in Venice in 1775 and was previously situated in a suppressed convent in the Venetian States. There is earlier documentation confirming that the Titian signature and date were apparent in 1775. It contains a portrait of Titian and very probably several other portraits, as we have seen. The evident relationship to the Louvre *Self-portrait with Friends*, portraying a young red-haired Titian with noticeable similarities to our apostle, provide further indications as to our attribution. We then find the monogram of Titian's long-term collaborator, Girolamo

Dente, the date of Titian's death above his portrait, significant identification of the master by comparison with the Prado *Self-portrait* and profile drawing, and finally – but conclusively – the tiny but identifiable Titian signature on the jug.

This study of the Ledbury *Last Supper* has taken myself and my researcher three years to complete. We do not believe more can be discovered unless new documentation emerges. The subject of Titian's workshop is extremely complex and not well understood, as many art historians have pointed out from the time of Vasari to the present day. Many hundreds of hours were initially spent trying to determine the workshop responsible and then the quote from Skippe surfaced, the purchase date of 1775 and, most importantly, he wrote of Titian, 'his name and a date are upon it'. This then enabled the full technical examination to have real purpose and the various faint inscriptions were discovered and their significance has been addressed in this book.

It should be said that Skippe purchased many paintings, particularly in Venice, which he sent home to Ledbury, and his inventory and the later sales catalogues suggest a plethora of important names.

As we noted at the beginning of the book, Skippe was an accomplished artist, especially in drawing in an Old Master style, and his extensive travels to view artworks together with his interest in drawing them surely taught him a great deal. We have no visual record of his other Venetian purchases and all seem to have been sold over a long period, but in this, his *Last Supper*, he was highly perceptive and discovered what is certainly one of the very last large-scale paintings and *Last Suppers* to leave Titian's workshop at Biri Grande in Venice.

1. D. Rosand, 'Self-portrait in Profile', entry in *Tiziano, the Last Act*, catalogue of the Belluno exhibition, September 2007–January 2008.
2. M. Falomir, *El Retrato del Renacimiento*, Museo Nacional del Prado, 2008, p. 492.

BIBLIOGRAPHY

B. Aikema, Annette Kranz, Christoph Amberger, etc, in *Studi Tizianeschi*, 111, 2005.

A. Ballarin, 'Profilo di Lamberto d'Amsterdam' (on Sustris), *Arte Veneta*, 1962.

C. Bambach, *Drawing and Painting in the Italian Renaissance workshop: Theory and Practice*, Cambridge, 1999.

M. Baxandall, *Painting and Experience in Fifteenth-Century Italy: A Primer in the Social History of Pictorial Style*, Oxford, 1988.

B. Berenson, *The Study and Criticism of Italian Art: Italian Pictures of the Renaissance*, London: Venetian School, 1957.

M. Boschini, *Le Ricche Minere della Pittura Veneziana*, Venice, 1674.

M. Biffis and G. Tagiaferro, *Emanuel Amberger e I Battuti di Serravalle*, Venezia Cinquecento, XVII, 2007, pp. 77-102.

L. Campbell, *Renaissance Portraits: European Portrait Painting in the Fourteenth, Fifteenth and Sixteenth Centuries*, Yale, 1991.

G.B. Cavalcaselle and J.A. Crowe, *Titian: His Life and Times*, Florence, 1898.

K. Clarke, *Leonardo da Vinci*, Cambridge University Press, 1939.

K. Clarke, *Leonardo: Catalogue of the Drawings at Windsor Castle*, 1935.

Claut, 'All'ombra di Tiziano, Contributo per Girolamo Dente', *Antichita Viva*, XXV, 1986, pp. 16-29.

R. Cocke, *Veronese's Drawings: A Catalogue Raisonné*, London: Sotheby's, 1984.

R. Cocke, *Veronese*, Phaidon, 1980.

E.M. Dal Pozzolo, 'La "bottega: di Tiziano: sistema solare e buco nero', *Studi Tizianeschi*, IV, 2006, pp. 53-98.

A. Donati, 'The Four Seasons by Girolamo Dente and his role in and outside Titian's workshop', Independant.academia.edu.

A. Donati, *The Four Seasons*, Madrid: Coll e & Cortes, 2013.

J. Dunkerton et al., 'Titian's Painting Technique from 1540', National Gallery technical bulletin, vol. 36.

N. Faas, *Pittori Tedeschi. De Landschapsschilders van Titiaan*, Leiden, 2014.

G. Fiocco, 'Profilo di Francesco Vercelli', *Arte Veneta*, VI, 1953, pp 39-48.

R. Fisher, 'Titian's Assistants during the Later Years' (PhD thesis, Harvard University, 1958), 1977.

G. Fossaluzza, *Among the disciples of Tiziano*, Osservatore Romana, 2010.

J. Grabski, 'The Contribution of Collaborators in Titian's Late Works', *Artibus et Historiae*, no. 67, vol. 34, 2013, pp. 285-310.

M. Gregori, 'Sul venetismo di Simone Peterzano', *Arte Documento*, 1992.

Hope and Asperen de Boer, *Underdrawings by Giorgione and his circle, Le Dessin Soujacent dans la peinture*, 1991.

F. Ilchman et al., *Titian, Veronese, Tintoretto. Rivals in Renaissance Venice*, Lund Humphries, 2009.

Marani, *Leonardo da Vinci, the Complete Paintings*, Abrams, 1999.
V. Mancini, *Polidoro da Lanciano*, Lanciano: Casa Editrice Rocco Carabba, 2001.
K. van Mander, *The Lives of the Illustrious Netherlandish and German Painters, 1603–1664*, 1994.
B.W. Meijer, 'Titian sketches on canvas and panel', *Master Drawings*, 1981.
B. Meijer, 'New light on Christoph Schwartz in Venice and the Veneto', *Artibus et Historiae*, 1999, 39.
S. Momesso, *Bernardino Licinio (l'eco di Bergama)*, 2009.

National Gallery technical bulletin, 'Titian's Bacchus and Ariadne', 1978.

Orliac, *Veronese*, Paris, *c.* 1960.

R. Pallucchini, *Una Nova opera di Francesco Vercelli a Monopoli*, Paragone, 1962.
E. Panofsky, *Problems in Titian, mostly iconographic*, London, 1969.
A. Paolucci, *The Titian Firm*, Rome: L'Osservatore Romano, 2010.
M. Pavesi, 'A dinner in Emmaus by Simone Peterzano', *Nuovi Studi*, 2016.
N. Penny, 'Two Paintings by Titian in the National Gallery London. Notes on technique, condition and provenance', *Tiziano tecnicas*, 1999, pp. 109-16.

C. Ridolfi, *Le Maraviglie dell'Arte*, Padua, 1648.
F. Russell, 'A portrait by Orazio Vecellio', *Studi Tizianeschi*, 2007.

G. Tagliaferro, B. Aikema, M. Mancini and A.J. Martin, *Le Botteghe di Tiziano*, Florence: Alinari, 2009.
G. Tagliaferro, *In the workshop with Titian 1548–1576*, Venice, 2008.
G. Tagliaferro, 'La Bottega di Tiziano: un percorso critico', *Studi Tizianeschi*, IV, 2006, pp. 16-52.
E. Tietze-Conrat, 'Titian's workshop in his late years', *The Art Bulletin*, Vol. 28, no. 2, 1946, pp. 76-88.
E. Tietze-Conrat, *The Drawings of the Venetian Painters in the Fifteenth and Sixteenth Centuries*, New York, 1944.
E. Tietze-Conrat, 'Titian's workshop in his late years', *Art Bulletin*, XXV, 111, 1948.
H. Tietze, 'An early version of Titian's "Danae": An analysis of Titian's Replicas', *Arte Veneta*, 1954.

Giorgio Vasari, *Le Vite dei piu eccellenti pittori, scultori e architetti*, Florence, 1568, 1906.

H.E. Wethey, *The Paintings of Titian*, 3 vols, Phaidon, 1969/1975.
H.E. Wethey, *Titian and His Drawings*, Princeton, NJ: Princeton University Press, 1987.

J. Żarnowski, 'L'atelier de Titien, Girolamo di Tiziano', *L'Art ancient, Revue d'Archaeologie et d'Histoire de l'Art*, 1938, pp. 107-29.

LIST OF ILLUSTRATIONS

INDEX